ONONDAGA

ONON

DAGA

Portrait of a Native People

Preface *by* DENNIS J. CONNORS
Foreword by LAURENCE M. HAUPTMAN
Introduction by RAY GONYEA
Photographs by FRED R. WOLCOTT

ONONDAGA COUNTY DEPARTMENT OF
PARKS AND RECREATION

SYRACUSE UNIVERSITY PRESS
in association with EVERSON MUSEUM OF ART

This publication is made possible in part with public funds from the New York State Council on the Arts.

This book is published with the assistance of a grant from the John Ben Snow Foundation.

The majority of photographs in this publication were produced from the original glass plate negatives contained in the Museums Collection of the Onondaga County Parks Department. Anyone who may have additional identification information, or is interested in securing reproductions, should contact the Office of Museums and Historic Sites/Onondaga County Parks Department/PO Box 146/Liverpool, New York 13088.

The paper used in this publication meets the minimum requirements of American National Standard for Information Sciences—Permanence of Paper for Printed Library Materials, ANSI Z39.48–1984. ∞

Library of Congress Cataloging-in-Publication Data

Wolcott, Fred Ryther, 1862–1946.
 Onondaga: portrait of a native people.

 (An Iroquois book)
 Catalog of the exhibition premiered Sept. 8, 1984,
at the Everson Museum, Syracuse; guest curator, Ray
Gonyea.
 Bibliography: p.
 Includes index.
 1. Onondaga Indians—Pictorial works—Exhibitions.
2. Wolcott, Fred Ryther, 1862–1946. 3. Indians of
North America—New York—Pictorial works—Exhibitions.
I. Gonyea, Ray. II. Onondaga County (N.Y.). Dept.
of Parks and Recreation. III. Everson Museum of Art.
IV. Title. V. Series.

E99.O58W65 1986 779′.997476500497 85-27686
ISBN 0-8156-0198-0 (alk. paper)

Contents

DENNIS J. CONNORS is Director of Museums and Historic Sites for the Onondaga County Parks Department. He graduated from State University of New York at Buffalo in 1973 and has fourteen years of historical agency experience. A resident of Syracuse, Mr. Connors serves on that city's Landmark Preservation Board and Urban Cultural Park Advisory Committee. He has authored instructional materials for use in Central New York school curricula, plus articles for *The Museologist* and the *Society for Industrial Archeology Newsletter*.

LAURENCE M. HAUPTMAN is Professor of History at the State University of New York at New Paltz. He is the author of *The Iroquois Struggle for Survival: World War II to Red Power* (Syracuse University Press), *The Iroquois and the New Deal* (Syracuse University Press), and co-editor of *Neighbors and Intruders: An Ethnohistorical Exploration of the Indians of Hudson's River*. Professor Hauptman holds a Ph.D. in American History from New York University.

RAY GONYEA, Onondaga (Beaver Clan), was raised on the Reservation of the Onondaga Indian Nation. He attended Marion College and Seattle Pacific University. Trained in museum work by the Museum Program of the Indian Arts and Crafts Board, Washington, D.C., he served in assignments as Acting Director of the Southern Plains Indian Museum, Anadarko, Oklahoma, and Acting Curator of the Museum of the Plains Indian, Browning, Montana. Returning to New York State, he was the Museum Director of the Native American Center For the Living Arts, Niagara Falls, and is currently Ethnology Specialist for the New York State Museum.

FRED RYTHER WOLCOTT was born in 1862 in the Jefferson County community of Theresa, New York. By the age of thirty-five, he had married, moved to Syracuse, and was working as a commercial sign painter. He changed to the field of both still and motion picture photography about 1904, and his work was often featured in the Sunday supplements of Syracuse newspapers. Fred Wolcott died in 1946 and is buried in Syracuse. His remarkable early twentieth-century photographs of the Onondaga reservation apparently constitute his most famous and intact series of surviving work.

ONONDAGA

Preface

DENNIS J. CONNORS

I n cooperation with the Everson Museum of Art, the Museums division of the Onondaga County Department of Parks is pleased to have organized this book to interpret seventy-one turn-of-the-century photographs of the Onondaga Indian Nation. They offer rare and compelling insights into life nearly a century ago on the reservation just south of Syracuse, New York.

The pictures are selections from a larger assemblage of glass plate negatives taken by Syracuse photographer Fred R. Wolcott between 1902 and 1917. Most of the original plates are in the collections of the Office of Museums and Historic Sites, a unit of Onondaga County Parks responsible for the operation of the Salt Museum and the Ste. Marie de Gannentaha living history site. A few of the images are copied from original prints in the collection of the Onondaga Historical Association.

Wolcott was a Syracuse photographer of the late nineteenth and early twentieth centuries. Although he died fairly recently, in 1946, he left little information behind about himself. His legacy, however, is firmly established in this collection of remarkable photographs.

Wolcott had a particular interest in the subject matter, apparently, as the dates of the photographs show he brought his camera to the reservation on several

1

occasions over nearly a fifteen-year span. Records in both 1906 and 1915 refer to his occupation as a "lecturer," the latter entry specifically on the topic of the Onondaga.

The County Parks Museums Office has owned the collection of glass plates for decades. In 1982 it was successful in securing funding from the New York State Council on the Arts to allow the fragile, original negatives, forgotten for more than sixty years, to be first copied, then printed and researched. A subsequent Council grant to the Museums Office allowed it to present them to the public by organizing a traveling exhibit and helping to underwrite this publication. The exhibition premiered on September 8, 1984, at Syracuse's Everson Museum. Beginning in early 1985, it began a 2½-year tour throughout New York State under the auspices of the Gallery Association of New York State.

Ray Gonyea served as guest curator for the exhibit and has contributed the Introduction to this publication. A member of the Onondaga Nation himself, Gonyea conducted extensive interviews with reservation elders to document the people and subjects depicted in Wolcott's previously unidentified photographs.

Laurence M. Hauptman, professor of history at State University of New York at New Paltz, offers an overview in his Foreword of Indian-white relations in New York State at the time of Wolcott's photos. He stresses that there were considerable pressures on the Onondaga during those years toward absorption into the mainstream of American culture. The Wolcott photos document their reactions to these pressures, while striving to maintain their traditions, and Hauptman finds these images to be a significant new tool for Iroquois history.

Gonyea brings a view of the photos from inside the reservation, and from inside the Onondaga. He calls the photos an important visual interpretation of what were the "in-between years" for the Onondaga, from the American Civil War to World War I. It was a time when "rapidly culminating pressures around the Onondaga pushed them toward the brink of total acculturation. . . . Many had adopted a non-Indian life style and had almost completely given up or lost most of their traditional culture."

Additionally, outsiders often blurred the critical distinctions between specific Indian nations. An American Indian stereotype developed, frozen in the past tense, and later fostered by hundreds of Hollywood movies. It helped obscure the Onondaga's distinctive Woodland culture. Turn-of-the-century photographers often posed Eastern Native Americans in the Western clothing of the Plains tribes so they would look more like the larger white society's idea of a real Indian. Their

2

existence as both a unique society and as individuals was often overlooked.

Some of this bias is evident in the Wolcott images. Generally, however, the photographer has captured an honest slice of reservation life at the time. The photos show us the residents of the reservation as individuals. Many of the images and poses are typical of those familiar in other early twentieth-century views of rural America: boys proudly showing off their bicycles, the local baseball team, the village church, or a family gathered on the front porch of their home.

Ironically, all these dramatically illustrate Gonyea's point concerning acculturation. Yet there are images that document a surviving core of traditional culture: a display of wampum, the work of a resident lacrosse stick maker, the scene at a condolence ceremony, and a centuries-old farming format.

The Onondaga did not fade away into the mainstream of American culture. They have continued to occupy their reservation down to the present day. These native people have struggled to preserve their integrity as a native society, while individuals found the need to adapt with the changing world around them.

This project has stimulated considerable interest on the reservation and a video documentary was produced as part of the exhibit. It showed interviews with three reservation elders. As they commented on the photos, they used them to discuss the Onondaga culture in a continuum—past, present, and future. The entire process emphasized that the Onondaga are not a static people.

The Onondaga County Parks Office of Museums and Historic Sites was privileged to act as a catalyst for both the exhibit and this book. As its director, I am honored to be associated with the dedicated professionals who have staffed this organization since its inception in 1974. Special appreciation is due to Gregory Daily, staff exhibit artist, for his creative contributions to the project.

Additional funding for the exhibit came from the Friends of Historic Onondaga Lake, Inc., the Syracuse Savings Bank Fund of the Central New York Community Foundation, and from the people of Onondaga County through their County Legislature and its support of the Parks Department's programs.

The cooperation of the Everson Museum was essential for production of both the exhibit and this book. They also would not have been possible without the talents of David Broda, who reproduced all the required prints from Wolcott's original negatives. I would also like to thank Violet Hosler of the Onondaga Historical Association for assistance in locating additional Wolcott photographs and to Jean Daugherty and the staff of WTVH-5 for production of the exhibit's video documentary.

Appreciation is due to Laurence M. Hauptman for contributing his Foreword and sincere gratitude is owed to Ray Gonyea, not only for his Introduction, but also for his dedication and insight while conducting the primary research, without which this project would not have been possible. A special note of thanks is extended to Robert W. Venables for his help and support.

Finally, all who participated in this project are indebted to the members of the Onondaga Nation who volunteered their time, talents, and memories as resource people. They include Spenser Beckman; Delia and Dan Carpenter; Lavinia Beckman Crane; Helen Crouse; Rena and Floyd Doctor; Ray Elm, Sr.; Abbey Gibson; Sarah and Raphel Gonyea; Evelyn Lewis; Elsie Logan; Oren Lyons; Alice Papineau; Irving Powless, Sr.; Irving Powless, Jr.; Leon Shenandoah; Audrey Shenandoah; Amanda Tomlinson; and Dorothy Williams.

If these photographs generate a fuller awareness of the Onondaga on the part of those outside the reservation and bring to the Onondaga a renewed appreciation of their own culture, then this publication will be a success.

Foreword

LAURENCE M. HAUPTMAN

Historical photographs have been defined as offering believable images of times past "capable of supporting the study or the interpretation of history."[1] Do the Wolcott photographs meet that criterion? If these photographs are to be useful for historical research, we must try to understand them in the context of the Indian and non-Indian worlds of the late nineteenth and early twentieth centuries. Although we know so little at this stage about Wolcott, his preconceived notions of Indian life, and his motivations for undertaking the project, we gather from even a casual glance at the photographs that he was viewed warmly by some and as an intruder by others. Like the famous photographs of Edward S. Curtis, a contemporary who with a camera attempted to document the mores and social behavior of the so-called vanishing cultures of North American Indians, some of the Wolcott photographs appear staged and manipulated. Consequently, we should not lose track of the potential bias present in the photographs and that this artistic genre often tells more about the non-Indian world's perception of reality than about Indian life.[2]

1. Robert A. Weinstein and Larry Booth, *Collection, Use and Care of Historical Photographs* (Nashville, Tenn., 1977), pp. 4–5. I have benefited in reading Thomas J. Schlereth's *Artifacts and the American Past* (Nashville, Tenn., 1980), pp. 11–47, and Walter Rundell's "Photographs as Historical Evidence," *American Archivist* 41 (October 1978): 379–98.
2. Joanne Scherer, "You Can't Believe Your Eyes: Inaccuracies in the Photographs of North American Indians," *Studies in the Anthropology of Visual Communication* 2 (1976): 67–78. See also Christopher M. Lyman, *The Vanishing Race and Other Illusions: Photographs of Indians by Edward S. Curtis* (Washington, D.C., 1982).

With these limitations in mind, we must conclude as students of Iroquois history that these photographs *are a major find* and that they substantially meet the criterion for historical photographs. They are especially helpful in supplementing our oral and written archival records, helping us to better understand, among other things, architectural changes, kinship relationships, the outside pressures on the Onondaga community, and the remarkable cultural persistence and survival of Iroquois peoples.

The noted historian Alan Tractenberg has observed about the use of photographs for historical interpretation: "Like all pictures, photographs invite interpretations, but the interpreter needs some controls upon his imagination, some limits, and a boundary between sense and non-sense."[3] The purpose of this Foreword is to attempt to provide such a boundary. In order to better understand the photographs, I will describe the pressures on the Iroquois during these in-between years from the American Civil War to World War I.

American Indians in the second half of the nineteenth century were faced with a prevailing white societal attitude that sought to absorb native peoples into American society through a four-pronged formula of forced assimilation. This so-called Americanization process included (1) the Christianizing activities of missionaries on reservations in order to stamp out "paganism"; (2) the exposure of the Indian to white Americans' ways through compulsory education and boarding schools such as Carlisle, Hampton, and Lincoln institutes; (3) the break-up of tribal lands and allotment to individual Indians to instill personal intitiative, allegedly required by the free enterprise system; and finally, in return for accepting land-in-severalty, (4) the "rewarding" of Indians with United States citizenship.

These premises, strange as it may seem today, were advocated even by such prominent reform groups as the Indian Rights Association, the Women's National Indian Association, the Lake Mohonk Conferences of Friends of the Indian, and the United States Board of Indian Commissioners. Exhibiting a Social Darwinism bias and advocating a similar paternalistic approach, these reformers believed that responsible men of affairs owed an obligation to what they considered "weaker races." Behind these attitudes was the seldom-challenged assumption that it was possible to kill the Indian but save the man.

3. Alan Tractenberg, "Photographs as Symbolic History," in *The American Image: Photographs from the National Archives, 1860–1960,* National Archives and Records Service, comp. and ed. (New York, 1979), p. xix.

Most of the 5,000 reservation Indians in New York in 1890 did not share the reformers' views. Most believed that it was not worth saving the man at the expense of killing the Indian. They rejected Americanization; rather, they preserved tribal identity by retaining their separate existence, speaking their own languages, performing their ceremonies, continuing to observe their native religion, not pushing for suffrage, and viewing themselves as citizens of sovereign enclave nation-states. In short, point for point, many Indians, although not all, were in opposition to each and every item in the reformers' Americanization blueprint.[4]

In spite of these pressures, the Onondagas were more successful than most Indians of the period in resisting change. Although losing much of their 100-square-mile reservation after 1788 because of the greed of land speculators and white population pressures in central New York, the Onondagas did succeed in warding off the final push for allotment of their remaining 6,100-acre homeland in the 1870s through the early twentieth century. This achievement, and that of the Seneca Nation under similar circumstances, is most remarkable when compared to the more numerous Five Civilized Tribes of the Oklahoma Territory who were also exempted from the Dawes General Allotment Act of 1887 but succumbed within a decade to the movement for land in severalty. Even the Onondagas' Iroquoian kin in Wisconsin and Oklahoma—the Oneidas and Seneca-Cayuga—could not stem the tide of "American Progress," each losing 99 percent of their 65,000-acre estate under the misworkings of the Dawes Act.[5]

Despite the outward appearances in some of the Wolcott photographs, the Onondagas were also more resistant to cultural-social-religious pressures than other Iroquois in New York during these years. It is clear that the influence of the Iroquois prophet, Handsome Lake, on the reservation in the early years of the nineteenth century, helped insulate and shape the Onondagas, even more than other Iroquois people, from the outside. Handsome Lake, who visited and preached there, died and was buried at Onondaga in 1815. Soon the Longhouse at Onondaga attracted the largest number of followers, and the Onondaga chiefs, who constituted the governing council of the reservation, continued to be ad-

4. See Laurence M. Hauptman, "Governor Theodore Roosevelt and the Indians of New York State," *Proceedings* of the American Philosophical Society 119 (February 1975): 1–7; and my "Senecas and Subdividers: The Resistance to Allotment of Indian Lands in New York, 1887–1906," *Prologue: The Journal of the National Archives* 9 (Summer 1977): 105–16.
5. Laurence M. Hauptman, *The Iroquois and the New Deal* (Syracuse, N.Y.: Syracuse University Press, 1981), chapters 5 and 6.

herents of the Longhouse religion. Although there were frequent calls from a small group of Onondagas, all converts to Christianity, who wanted this hereditary system abolished and replaced with an elected one, this change was not forthcoming. Out of 494 reservation residents (including 86 Oneidas) in 1890, there were only 23 professed Methodists, 21 Wesleyans, and 24 Episcopalians. Despite the frequent visits of Episcopal, Methodist, Presbyterian, and Quaker missionaries and the building of a Methodist and an Episcopal church as well as an Episcopal school in the nineteenth century, a minority of Onondagas were converted.[6]

New York State's educational thrust, largely geared to assimilating Indians, was also met with substantial resistance from the time of the establishment of the first public school on the reservation in the 1840s. Superintendent's reports from the Onondaga school are filled with descriptions of cosmetic changes in the appearance of the school or playground, with the frustrations of educators at getting the Indians to attend, and with explanations about why the schools were failing, with the blame placed entirely on the Indians. In one school report for 1888, the superintendent observed revealingly: "With so much done for them, why should not the Indians be happy and prosperous?" He then went on to answer his own question, blaming what he claimed as the lack of advancement on Indian "race customs," "practical communism" of the Indians, and the Onondaga chief's alleged authoritarian rule. He concluded:

> White men are strongly influenced by rewards and punishments, here and hereafter. Between heaven above and hell beneath, some whites are kept in the straight and narrow path; but take from our race the hope of future reward and the fear of future punishment, remove the prize of life, wealth, office, family ties, make the payment of pecuniary obligations entirely voluntary—in short, place our whites under the same system as the Indians, and deterioration must follow.[7]

A New York State Legislature special committee a year later, in 1889, gave further proof to Indian resistance to assimilationist education: "The majority of

6. U.S. Bureau of the Census, *The Six Nations of New York*, Extra Census Bulletin of the 11th Census of the U.S., 1890 (Washington, D.C., 1892), pp. 6–9.
7. New York State. Department of Public Instruction. *34th Annual Report of the State Superintendent, 1888* (Albany, 1888), p. 763.

the Indians on this reservation are unfriendly to the schools, and as a result they do much to discourage the children in attending."[8] As late as 1897, of 125 school-age children on the Onondaga Reservation, only 40 pupils attended on an average day.[9]

The pressures on the Onondagas reached their zenith in the last two decades of the nineteenth century. In 1888, the New York State Assembly appointed a special committee to investigate the "Indian problem." Their report, named after the committee's chairman, J.S. Whipple of Salamanca, New York, was issued on February 1, 1889. This Whipple Report, followed by similar ones in 1900 and 1905 by other state investigations, concluded that the "Indian problem" could be solved only by ending the Indians' separate status, giving them full citizenship, and absorbing them "into the great mass of the American people." The Whipple Report, which cited the testimony of disgruntled Onondaga political leaders as well as the testimony and earlier studies conducted by Dr. C. M. Sims, Chancellor of Syracuse University, described in its cultural myopic way the conditions on each New York reservation. Without question, the report had its harshest words for the Onondagas since both missionaries and state officials apparently were most frustrated in dealing with their conservatism and resistance to change. With no understanding of cultural relativism, the report condemned the traditional governmental leadership on the reservation as "corrupt and vicious," characterized the religious practices as depraved, immoral, and superstitious, and described the social and industrial state as "chronic barbarism." It insisted: "Their present condition is infamously vile and detestable, and just so long as they are permitted to remain in this condition, just so long will there remain upon the fair name of the Empire State a stain of no small magnitude."[10]

The Whipple Report maintained that reservation lands be alloted in severalty among tribal members with suitable restrictions as to alienation of whites and protection from judgments and debts. It urged the extension of state laws and jurisdiction over the Indians and "their absorption into citizenship." Finally, the report concluded: "These Indian people have been kept as 'wards' or children long

8. New York State. *Assembly Report No. 51: Special Committee to Investigate the Indian Problem of the State of New York Appointed by the Assembly of 1888* (Albany, 1889), p. 41 (hereafter cited as Whipple Report).

9. New York State. Department of Public Instruction. *44th Annual Report of the State Superintendent, 1897* (Albany, 1898), p. 555.

10. *Whipple Report*, pp. 41–45.

enough. They should now be educated to be men, not Indians, in order to finally once and for all solve the 'Indian problem'"[11]

The Whipple Report and subsequent state and private investigations of the Indian problem which followed in 1900, 1905, and 1914 colored Indian-white relations in this period and produced longstanding bitterness well into the twentieth century. Any movement by the federal and/or state governments to change its existing relationship with the Indians was met by determined resistance by conservative reservation communities. Citizenship and suffrage, two liberal progressive goals of the non-Indian world, were repeatedly viewed as the first stage in absorbing the Iroquois, taxing them, and taking their remaining landbase.[12]

I have intentionally wandered far and wide in attempting to provide "boundaries" to help interpret the Wolcott photographs. American concepts of "progress" and the worlds of Albany state government, of Central New York and even of the City of Syracuse were impinging on the insulated world of Onondaga during the period from the American Civil War to World War I. I have attempted to describe those pressures. For the people of the Great Law, these threats to order were real; however, perhaps because of their inward self-assuredness and their own concepts of rightness which grow out of their native religious beliefs, they persisted and survived the onslaught. Even though the Wolcott photographs indicate substantial outward change in Onondaga life, interpreters of Iroquois life, whether they are historians, anthropologists, art historians, photographers or others, should be aware that Iroquois society is always changing and never static. They should also realize that Iroquois traditionalism survives hidden beyond the apparent "new" forms, as Morris Freilich has indicated in his studies of Iroquois ironworkers.[13] The meaning of these photographs is in the vitality and strength of the Iroquois way at a time of increased and overwhelming pressures to conform and to abandon tradition. With this in mind, the researcher using the Wolcott photographs has without question one of the better untapped sources on Iroquois history.

11. *Ibid.*, pp. 78–79.
12. Hauptman, *The Iroquois and the New Deal*, chapters 1–4.
13. Morris Freilich, "Cultural Persistence Among the Modern Iroquois," *Anthropos* 43 (1958): 473–83.

Introduction

RAY GONYEA

The exhibition "Onondaga: Portrait of a Native People" was a visual interpretation of an important period in the history and development of the Onondaga Nation spanning the period from the end of the Civil War to the first World War. It was a period of change throughout the United States and the world. Many of the social, economic, and political traditions that affect our lives today have their roots in that time. These, in turn, wrought powerful forces that accelerated the acculturation of the Onondaga Nation. Rapidly culminating pressures around the Onondaga pushed them toward the brink of total acculturation. During this period they stood at the brink, glimpsing the cultural abyss beyond from which no one returns as a people, and stepped back.

This period began with the Onondaga Nation's adopting selective elements of the non-Indian world into their culture, such as clothing and farm equipment, but always retaining a core of their culture that was distinctly Iroquois. At the height of these "in-between years" many had adopted a non-Indian life style and had almost completely given up or lost most of their traditional culture. By the end of this period, however, the Onondaga had stepped back from the brink and had begun a soul-searching process of sorting out who and what they were. They began a return to selective adoption from the non-Indian world which continues to the present day. They returned to the core of their culture that they had found to be uniquely their own. In the following years they would sharpen these newly reclaimed old traditions and reconfirm and strengthen their convictions.

11

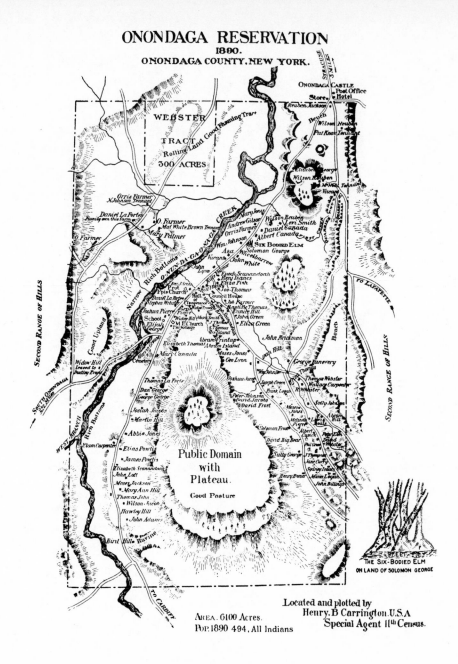

ONONDAGA RESERVATION
1890.
ONONDAGA COUNTY, NEW YORK.

From *Onondaga's Centennial: Gleanings of a Century*, Volume II, edited by Dwight H. Bruce
(Boston History Company, 1896), 1049.

THE FOUNDATION OF THE IROQUOIS CONFEDERACY

The history of the individual nations of the Iroquois Six Nations Confederacy cannot be properly understood without a basic knowledge of the founding of the Confederacy itself. This encompasses the work of the Peace Maker and Hayentwatha among the Iroquois people and their creation of the Great Peace and Great Law. Out of respect for this great contribution to the Iroquois people, the given name of the Peace Maker is never spoken, and he must only be referred to as "the Peace Maker."

What is known about the founding of the Confederacy is embodied within the Great Law itself, which was originally recorded in the minds of the people and reminded to them by mnemonic devices like belts and strings of wampum and passed from generation to generation by its keepers. Even to this day, the coming of the Peace Maker and the founding of the Great Law is recited in the council houses of the Six Nations modified only by the fact that the complete records of wampum are no longer in the hands of the keepers but are scattered around the world in museums and private collections. It is not known exactly when this unification happened because it occurred before written history in North America. When Europeans arrived and first began hearing of this League of Nations, it was referred to, by all, as being ancient.

The period before the coming of the Peace Maker was a dark time of undetermined length filled with fear and death. Although of common ancestry, the Iroquois Nations, as they began expanding throughout what is now central New York State, began quarreling and then warring among themselves. It was a time of constant mourning, blood feuds, and hunger. Brother opposed brother. People feared speaking to anyone and did not go outdoors unless in numbers and heavily armed and never at night. There was a complete breakdown of social order. To make matters worse, their enemies, undoubtedly finding them easy targets in their turmoil, were relentlessly attacking them.

The Peace Maker, a Huron Indian, came to the Iroquois and began preaching a message of peace, reason, law, and the abolishment of war. He invited them to join him in an effort to unite the Iroquois people in a confederacy under one law. The people, tired of anarchy, listened eagerly and joined him. Hayentwatha was an established and respected Onondaga chief known for his oratorical abilities and was one of the Peace Maker's early converts. Together these two men, with Hayentwatha serving as spokesman, embarked on a great campaign traveling east

to west across the length of the present New York State. It took them and their growing number of followers from the Mohawk Nation along the Mohawk River to the Seneca Nation along the Genesee River. They won over four of the Iroquois Nations: the Mohawk, Oneida, Cayuga, and Seneca. Now, they turned eastward again to confront the head chief of the Onondaga Nation, Tohdadaho, an astute politician who ruled and maintained his power through absolute fear. They arrived at his village on the eastern shore of Onondaga Lake near the present site of Syracuse, New York. With their followers and the chiefs of the four nations they convinced Tohdadaho to join them by overwhelming him with their political and military power. He had no alternative but to reevaluate his political future. Through the influence of Hayentwatha, he changed his despotic methods because they were no longer needed. The dark time was over and the Five Nations were at peace with one another. Later, in the early 1700s, the Tuscarora Nation was admitted, expanding the confederacy to Six Nations.

The Peace Maker convened the first Grand Council by designating the new Chiefs of the Confederacy and placing on their heads an Iroquois headdress with deer horns affixed as a symbol of their office. The Great Law had been recorded on belts and strings of wampum during the great campaign and now, taking each in his hands in turn, the Peace Maker recited the Great Law for the people. It codified the entire structure of the Six Nations government based on a family system divided into clans. It specified the number of each nation's representatives, their titles and duties, where, how and how often they should meet. It stipulated how they should deal with such issues as war and the raising up of new chiefs. It guaranteed freedom of assembly, religion, speech, and universal suffrage. If it had been enacted in a later time it would have been called a constitution. It is formally called the Great Binding Law and it united the Iroquois people into an awesome political and military force that would make itself felt around the world. Although it guaranteed far more individual freedoms than the Magna Carta (1215), a much-heralded milestone from about the same period, it has received little recognition as such.

IROQUOIS INFLUENCE ON THE UNITED STATES

The government structure of the Six Nations greatly influenced the thinking of the

Founding Fathers of the United States as they sought to develop an independent government prior to the Revolution. Detailed knowledge of the workings of the Iroquois government was quite common. Colonial leaders had many opportunities for direct contact with the Iroquois. By the late 1600s the Iroquois had conquered practically all of the Indian nations north of the Carolinas and forbade them to make important decisions, such as land sales, without their approval. Therefore, all of the northeastern colonies would have to have had official contact with the Six Nations in order, for example, to acquire the western portions of their colonial territory. Indeed, capitalizing on the importance of the Iroquois in colonial affairs, the colony of New York quickly gained control of the contacts made by other colonies with "their" Indians, the Six Nations, and insisted that all official contact be made through Albany.

When the Dutch arrived in New York in 1609 and later began acquiring lands on the upper Hudson from the Mohawks, they held occasional conferences with their neighbors, the Iroquois. The English, however, replacing the Dutch in 1664, held more frequent conferences and published an annual Indian Affairs report beginning in 1675 with the establishment of the office of Secretary of Indian Affairs. After 1690, they held annual conferences in Albany with the Six Nations that were widely known and attended by colonial leaders. It was from these early contacts that quotes from the Great Law were first recorded. In 1727, Cadwallader Colden, renowned scientist, scholar, and friend of Benjamin Franklin, published his best seller, *History of The Five Nations*, which was widely read. From 1736 to 1762 Benjamin Franklin published the proceedings of treaty meetings with Native Americans, many of them with the Six Nations, in book form that interpreted them for the general public.

In 1751 Franklin wrote: "It would be a very strange thing, if six nations of ignorant savages should be capable of forming a scheme for such a union, and be able to execute it in such a manner, as that it appears indissoluble; and yet that a like union shall be impracticable for ten or a dozen English colonies." And in 1754 Franklin's first Plan of Union presented to the colonies at the annual Albany Conference was largely based on the Six Nations government, even to the extent of calling the legislative body the Grand Council. Although the representatives of the colonies at the conference accepted the plan, the individual colonial governments rejected it as a threat to their independence.

There are striking parallels between the Iroquois Confederacy and the government structure of the United States. For example, both are composed of three

branches: the Judicial (the Great Law and its Keepers), the Executive (Onondaga Nation), and the Legislative branch composed of two separate houses, the Senate (the Elder Brothers—Mohawk and Seneca) and the House of Representatives (the Younger Brothers—Oneida and Cayuga). The two Iroquois "houses" are based on the tradition that the Onondaga, Mohawk, and Seneca are from the original Iroquois stock and that the Oneida and Cayuga branched from them. A matter to be considered by the Grand Council is first introduced to the Elder Brothers for discussion and decision and then is "passed over the fire" to the Younger Brothers for their action. They then pass it on to the Onondaga who make the final decision. The Onondaga are like the Executive Branch in that they hold the head chief title, Tohdadaho, comparable to the President. They call, open, and close the Grand Council, determine the agenda, and make the final determination on Confederacy matters by confirming or vetoing the action of the two "houses" or by breaking a deadlocked vote between them. They are also the Keepers of the Wampum which include the Great Law and administrative records. In addition, their council house, now south of the present city of Syracuse, New York, is the "capital" of the Six Nations Confederacy and is where the Grand Council still meets. Although each nation has a set number of representatives on the Grand Council (the Onondaga have fourteen, for example), each nation has only one vote. And unlike the United States government, which requires a majority vote on each decision, the Grand Council must be unanimous throughout the entire process. And preeminent over all, giving guidance and direction, protecting all, is the Great Binding Law.

THE SIX NATIONS AND THE AMERICAN REVOLUTION

The Iroquois Six Nations Confederacy was at the height of its power from 1675, when they defeated the Susquehannah Nation, until the start of the Revolution in 1776. They had vanquished their Native American enemies, and they now controlled a vast empire that stretched from New Hampshire to Lake Michigan, from the Hudson Bay to Tennessee. All nations within this area paid tribute and homage to the Six Nations. They were controlled by a proconsul-like system that allowed a large degree of self-government.

However, the Six Nations, because of their power, influence, and strategic location, found themselves increasingly caught between warring European nations, with each side competing for their military alliance. First the Dutch sought their assistance against the English, then the English against the French, and finally the British against the Americans. They had allied themselves with the English in successive wars against the French, but during the American Revolution they could turn neither on a long-time ally nor against their neighbors, the Americans. Furthermore, they did not trust the Americans' lust for Indian land despite repeated assurances to the contrary. Tradition states that the necessary unanimous vote could not be obtained, either way, and so the Grand Council decided to "cover the fire." In effect, they declared themselves neutral by deciding not to decide. The Americans, aware of their sentimental ties to England and fearing their military power, preferred to have them neutral if not an ally. Unfortunately, in the Six Nations' legislative process, this meant that the decision was now left to the individual nations. The Seneca and Mohawk declared for the British, as did many individuals of the other nations, while the Oneida were staunch allies of the Americans throughout the war. It is important to remember that the Iroquois Six Nations Confederacy, as an entity, did not side with the British during the war.

The Americans, however, did not make this distinction with Iroquois warriors joining in attacks on their flanks. To neutralize this threat the United States launched a devastating attack on the Iroquois homelands in the Clinton-Sullivan Campaign in 1779. Under the specific order of General George Washington, the campaign, planned for that summer, was to trap the Cayuga and Seneca in a pincer movement. Major General John Sullivan marched north from Eaton, Pennsylvania; Brigadier General James Clinton marched southwest from the Mohawk River valley, and Colonel Daniel Brodhead marched northeast up the Allegheny River valley from Fort Pitt in western Pennsylvania. The combined armies, joining forces in the Genesee River valley, were then to march on and capture Fort Niagara as a secondary objective.

In April of that year, to prevent the Onondaga from aiding the Seneca and Cayuga later during the main action, Colonel Goose Van Schaick led a preemptive strike from Fort Stanwix and attacked and burned the main Onondaga village, the "capital" of the Confederacy, then located along the bottomlands of Onondaga Creek below the present town of Nedrow, south of Syracuse, New York. Because they were long forewarned of the approaching force there were few

Onondaga casualties. However, the destruction of their main village forced them to relocate southward up the creek valley where they presently reside.

Although the campaign was a military failure it was successful in destroying the economic base of the Iroquois. Brodhead turned back before linking forces, so they did not march on Fort Niagara and the whole campaign had only one major battle. With little fighting to do, the troops busied themselves by destroying everything Iroquois in sight. The campaign destroyed forty towns, an estimated 200,000 bushels of corn, thousands of bushels of beans and potatoes, and thousands of fruit trees. Orchards of apple, pear, and peach trees that had been developed since trading with the Dutch more than a hundred years before were destroyed. Although no new territory was held, the Clinton-Sullivan Campaign was heralded by all but the Six Nations as the "conquest" of the Iroquois. In term of destruction and effect, Sherman's march to the sea during the American Civil War is a striking parallel.

The Clinton-Sullivan Campaign galvanized the Six Nations against the Americans and resulted in more Iroquois joining the British independently. This expedition is also the source of the Iroquois name for George Washington and hence all United States presidents after him: Ha-no-da-ga-ne-ars which means "Destroyer of Villages" or, simply, "Town Burner."

The Revolution also had the traumatic effect of dividing the Confederacy into "two fires." By the end of the war the British sympathizers had fled to Canada where they established another Six Nations government that functioned as a separate entity until 1925 when the Canadian Indian Act forced an elective system on them. Since then, the traditional Canadian Iroquois have returned to the central fire at the Onondaga Nation in New York State.

The end of the Revolutionary War and the defeat of the British brought new problems for the Six Nations and the Native American nations on the northwestern frontier. During the French and Indian War they had allied themselves with the British and accepted their military assistance. Somehow this was interpreted by Europeans and colonials as acceptance of British sovereignty over them and their land. In the terms at the end of the Revolution, the British, unknown to Native Americans, surrendered all their territory which was interpreted to include Indian lands. The British, at the opening sessions that led to the Treaty of Paris which ended the Revolution, attempted to separate English territory from Native American lands but gave in to the American demands. This gave the Americans a psychological edge that they used most effectively in negotiating the extinguish-

ment of Native American title to vast areas west of the Appalachian Mountains. The worst fears of the Native Americans before the war were now realized as hordes of settlers began pouring into the newly "conquered" lands once the British surrendered. The Northwest Ordinance of 1787 supposedly guaranteed that Indian lands could not be taken or disturbed without their consent. It was a desperate attempt to stem the intrusions but it failed. As a result, the war with the Native American nations continued in the Northwest Territories until 1795 although the Revolution was officially over in 1783. The nations stubbornly resisted with British assistance now that they had realized their diplomatic blunder. At one point, the United States even tried to get the Six Nations to use their influence to bring about an end to the war, since the contested area had once been part of Iroquoia, but the desperate times confounded any attempt to negotiate a settlement. Besides, the Six Nations were having their own land problems in New York State.

THE IROQUOIS GREAT DEPRESSION

The period following the Revolution was a time of severe economic depression for the Iroquois people brought about primarily by the devastation wrought by the Clinton-Sullivan Campaign during the war. Its effects continued to be felt through the end of the American Civil War. The destruction of the campaign, combined with the defeat of the seemingly all-powerful British, stunned the Six Nations. During the first fifty years of this period the Six Nations, through a series of treaties forced on them by the United States and, primarily, the State of New York, lost their lands. By 1842 they were left with reservations that are about the same size today. Stipulations in the Articles of Confederation (1781), the Northwest Ordinance (1787), the Constitution of the United States (1789), and the Non-Intercourse Act (1790) had specifically reserved treaty negotiations with Native Americans for Congressional enactment. Despite this, the State of New York independently negotiated treaties with the Iroquois under the guise of protecting and providing for them in their time of need. They, shrewdly, dealt with the individual nations rather than with the Confederacy government as would have been appropriate, and which they knew would have been the correct diplomatic procedure. Fortunately, these treaties have since become the subject of land claims by Iroquois Nations against the State of New York in the courts. The Onondaga

Nation, Keepers of the Central Fire, once held millions of acres in central New York state. It now found itself, as the results of a series of treaties with the state (1788, 1793, 1817, 1822), on a reservation of 6,100 acres at the close of this period.

The War of 1812 for Native Americans was a replay of their concerns in the Revolution. The Indian nations in the Northwest Territories included several Iroquois settlements from the days of Iroquoia. They all desperately attempted to maintain their lands and some form of independence from the United States through an intertribal alliance forged by Tecumseh. To the Native Americans their British allies were only a means to an end. But the British, attempting to rectify their diplomatic blunder of surrendering Indian lands at the end of the Revolution, were also looking out for their own interests in the lucrative fur trade. Although the Indian-British alliance did appeal to the Six Nations to join them, the Iroquois, again, chose to remain neutral. However, they could not prevent a considerable number of Iroquois warriors from joining the Canadian Iroquois as volunteers.

One of the most positive and enduring developments of this period were the visions of Handsome Lake that evolved into the Longhouse Religion. This has become the religion of traditional Iroquois today. Handsome Lake (Ga-ne-o-di-yo) was a Seneca Chief and a veteran of the Revolution and the Northwest Territories war. Beginning in 1799, he experienced a series of visions in which a message and a way of life for the people were revealed to him from the Creator. He began preaching the message. The Iroquois people were in the darkest throes of economic and spiritual depression. They were subject to the constant threat and fact of war and loss of their homelands. The previously insulating frontier had collapsed and they were now suddenly surrounded by an overpowering and unfriendly foreign culture. The now unrestricted availability of alcohol also produced its devastating effects. The chaotic times of social instability all came to a head and created a sense of helplessness and despair. None of the traditional means seemed to work any more.

Above the din of this turmoil, they heard a voice, the message of Handsome Lake. Incorporating much of the basic traditional culture in his message, he exhorted them to live virtuous and exemplary lives. He traveled from village to village, nation to nation (with the exception of the christianized Tuscarora, Oneida, and the far-way Mohawk villages) and met with delegations from as far away as the Iroquois settlements on the Sandusky River in Ohio. The people responded in such great numbers that, by the time of his death in 1815 on the Onondaga Nation, a true spiritual renaissance had begun sweeping the Iroquois

Nations. His teachings were largely responsible for keeping the Six Nations out of the War of 1812. After his death, his followers organized their remembrances of his teachings into a ceremony called the Gai-wi-io. Appointed preachers recite it each year among the faithful of the Longhouse Religion. The general area of his grave at Onondaga, near the present Council House, is marked by a granite monument (see photograph 67) erected to commemorate his contribution to the Iroquois people.

The American Civil War was viewed by the Six Nations as a war between brothers. However, many Iroquois volunteered for military service and served honorably with New York regiments across the state. Probably the most notable Iroquois participant in the Civil War was Eli Parker (Ha-sa-no-an-da), a Tona-wanda Seneca, who rose to the rank of Brigadier General. While on the staff of General Ulysses Grant, he penned the agreement of surrender signed by General Lee that ended the Civil War. Although he later served as America's first Native American Commissioner of Indian Affairs during President Grant's administration, his time in office brought no notable benefits for Native Americans.

THE IN-BETWEEN YEARS

The in-between years, following the Civil War and before World War I, marked an acceleration of the acculturation of the Iroquois toward an increasing involvement in the mainstream of American culture and away from their traditional culture. It is difficult to say when this movement began. Certainly it was further accelerated by the loss of important cultural material, such as the wampum and heirlooms. The development of peer influence on a personal level from outside the reservation, as interest and contact increased, and the renewed activity of the Christian churches played a part. Perhaps the return of veterans of the Civil War who had experienced the world outside of their close-knit community was a factor as well. It was a period that marked the beginnings of cultural confusion, where the Onondaga were to experiment with many aspects of their lives, including their cultural traditions, in order to learn what their true values were.

The houses of the Onondaga began changing from log cabins to frame houses prior to the in-between years. Log cabins had been in use by the Iroquois since the early 1700s, and perhaps experimented with earlier, as they obtained the necessary metal tools through the fur trade. In fact, the invading colonial soldiers with the

Clinton-Sullivan campaign in 1779 were amazed at the large number of fine log cabin homes they found and destroyed among the bark longhouses. Many were better than their own back home, with glazed windows and chimneys. There were even a few painted frame houses. The traditional bark longhouse, however, and combinations thereof, was not entirely discontinued until the 1800s. By the beginning of the in-between years, the construction of frame houses had already begun, primarily by the more well-to-do and progressive Onondaga (see photographs 23 and 31) while the traditional Onondaga preferred the log cabin (see photograph 22). By the year 1900, almost all homes were built of lumber, including the tribal Council House (see photograph 66).

It is interesting to note that the Iroquois production of their own furniture may have had some influence toward the development of the late nineteenth century "Adirondack" style of furniture popular in the summer lodges and camps in the Adirondack Mountain region of New York State. The rustic style is noted for its use of naturally shaped wood with bark left on, wood splints, and its use of sheets of natural bark. Beginning with the use of log cabins, the manufacture of rough furniture by the Iroquois for household use, often of natural shape and texture, was quite common. The use of natural wood and pressed sheets of bark for construction was the basic material for a Longhouse or temporary shelter, and wood splints were used in the making of baskets. Bark was the material used for many material culture implements such as containers and storage barrels. They were often decorated with design elements of contrasting kinds of bark. Although the use of manufactured furniture had begun prior to the in-between years, the making of natural-style furniture by the Iroquois continued throughout the period (see photographs 31 and 64); such furniture is still made by several individuals today.

Early in this period, the manner of everyday dress began to change from the traditional styles to the factory-made clothing of the Americans. Since the 1700s, when cloth goods became available through the fur trade, the Iroquois had incorporated fabrics into their dress but fashioned it in traditional styles and decorated with beadwork. Fabric was more colorful than deerskin and more practical because it was more readily available, generally lighter, and washable. As the game on their shrunken lands, now called reservations, became depleted and scarce, the use of fabrics became necessary. Native Americans were, and still are, practical people. They readily adopted new materials such as fabrics and metals but these were always adapted into a cultural framework and the end product was distinctly Indian.

During the in-between years, when everyday clothing began to be store-bought, there were still Onondaga who made traditional Iroquois-style clothing reserved for wear during ceremonies, special occasions, and burial (see photograph 43). It was also during the in-between years that the Pan-Indian movement began, combining cultural traits and art styles from other unrelated Indian Nations. As the American public became infatuated with the Western Indians, they began forming a stereotyped image of what a Native American was supposed to look like. Later, films and television would perfect this image that continues to this day. As a result, Onondaga traditional dress began to change. Combinations of Iroquois-style clothing with such elements as a modified Plains headdress (see photographs 46, 52, and 54) began to be worn. The outright use of Plains Indian dress was also coming into practice because it was becoming expected by the public. This development continued to grow and probably reached its height in the 1950s at the public celebration of the Green Corn Dance at Onondaga. However, the public image and the private one were two different things. There were always traditional Onondaga who continued to use Iroquois dress. In the 1960s, when the vogue began swinging back to traditional styles for public dress, their influence was needed.

One of the most important losses of Onondaga culture during the in-between years was the wholesale purchase of cultural material by private collectors and museums. This has had profound effects even to this day. Religious material, clothing, utensils, tools, silverwork, and all manner of family heirlooms were sold. There were such purchases before this period, as by the father of American anthropology, Lewis Henry Morgan, in the 1840s and later. However, the acquisition dates of the major collections of Onondaga ethnographic material seem to cluster around this period. Their loss is reflected in the beginnings of Pan-Indianism among the Onondaga, with cultural traits from other nations becoming incorporated into the Onondaga culture. Its most serious effect is the loss of identification with one's own cultural roots. The Onondaga were beginning to not know what Onondaga culture was because an important point of cultural reference was being removed. It was not enough to hear a traditional element of their culture described by an elder. Without a visual or physical contact, it was difficult to reproduce it. In time the tradition began to fade. This is a problem that all Native Americans continue to face today.

The various Christian churches have played an active role in the Onondaga Nation community since the early 1800s. The Episcopal Church established a

small mission in 1816 that flourished. In 1870, they acquired the church (see photograph 33) building and parsonage formerly occupied by the Wesleyan Methodists who had temporarily disbanded. In 1891, Albert Cusick (Sa-g-na-qua-ten or "He Who Makes Everybody Mad"), an Onondaga-Tuscarora (see photographs 43, 45, and 71) who had been a chief in the traditional government, was ordained deacon of this mission. Cusick contributed to the compilation of the Seth Newhouse version of the Constitution of the Six Nations for publication. The Methodist Church (see photograph 26) established a mission in 1829 and built the present church in 1848. It was remodeled and expanded in 1885. The Wesleyan Methodists reorganized and built their present church (see photograph 27) in 1895. One of the lay ministers of the Wesleyan Church during this period was Henry George (see photograph 12). The Seventh Day Adventist Church is also presently active.

During the in-between years, there was a more cooperative attitude between the Christian churches and the Longhouse religion than there is today. Indeed, there were Christians on the Council of Chiefs, and Council members often took part in church social activities and occasionally attended services. It appears that as long as the two were heading down the same path, that of acculturation, they peacefully coexisted. Both the Christian church and the Longhouse religion had positive effects in moderating the use of alcohol. One of the major themes taught by Handsome Lake dealt with abstinence from alcohol. He preached against its degrading effects which he had witnessed first hand during the Iroquois Great Depression. However, as the Onondaga Nation began moving back from the brink of total acculturation and began to reclaim languished traditions, the gap between the two began to widen. The churches saw a return to "heathen" ways, and traditionally minded Onondaga began to mistrust the acculturating influence of the churches. Although the Christian church had good intentions in trying to give the people strength during a trying period of confusion and uncertainty, it contributed to the rapid loss of their traditional culture. Although the church today and its methods of presentation have become more broadminded, distrust between both parties still exists.

In 1882, the Onondaga Nation, influenced by the organizational structure of outside fraternal groups, partially reorganized its government. It adopted a constitution that provided for a President or Chairman, Clerk, Treasurer, Marshal, three Peace Makers or Judges, a School Trustee, one Pathmaster, and two Poormasters. In addition, it adopted Roberts Rules of Order. This reorganization was supported by

the Christian elements. Gradually, the traditional element regained control of the council and by the end of this period traditional government was restored.

The Onondaga Council of Chiefs is composed of hereditary chiefs of all the clans represented among the nation's membership. Membership in an Iroquois nation is matrilineal and is determined by the mother. All children are the same nation as their mother. The chieftainships are held by the Clan Mother of each clan. A chief is selected from the eligible male members of the clan by the Clan Mother in counsel with the female members of the clan and with the agreement of the Council. The clans are composed of the women members of the nation and their families. Usually, the chieftainship remains in the lineage of a select family within the clan, but if an "eligible" candidate is not available a selection from another family is made or a candidate may be "borrowed" from another clan until a suitable candidate is available. In addition to the Council Chiefs, there are Pine Tree Chiefs, a War Chief, and other assistants who act as advisors and are not voting members. In time of war or other national emergency the War Chief heads the necessary action.

Each of the Iroquois nations is composed of clans, but the number may vary. For example, the Mohawk have three clans and the Onondaga eight. The Onondaga clans are Beaver, Turtle, Bear, Snipe, Wolf, Eel, Heron, and Deer. The clans of each of the Six Nations are considered as brothers and sisters. Therefore, an Onondaga Beaver and a Tuscarora Beaver, for example, share a kinship and for that reason marriage is forbidden between members of the same clan. Thus the clan system is a means of unifying the Six Nations by encouraging out-of-family marriages and interlocking family alliances between the nations.

Although the land of the nation is held in common by all members, the title for use of the land and major property, such as houses, is passed through the female line from the mother of a family to her eldest daughter. If a woman has no immediate female heirs, the property passes to a sister, so it always stays within the woman's family. An Onondaga man can own property individually, but, if he has not married on Onondaga woman, it passes to a sister or female member of his mother's family rather than to his children. Thus, if the tradition is correctly observed, the land of the nation will always remain within the nation. The lineage of the women remains unbroken as it spans the centuries back to the time of the Peace Maker.

During this period, the state of New York began and expanded its educational and medical services. The first permanent school building on the reservation

opened in 1887 on land set aside by the Onondaga for use by the state for that purpose. It replaced a dilapidated and little-attended one built in the 1850s. This new school was destroyed by fire in 1913 and was rebuilt (see photograph 39) but destroyed by fire again in 1937. After the fire in 1913, while its replacement was being built, the Onondaga children attended school on the second floor of Jake's Hall (see photograph 36) on Hemlock Road, today called Suicide Inn. The school began by providing an elementary through high school education, but during its several rebuildings it became just an elementary school with high school provided off the reservation. Many students also attended Carlisle Indian School in Pennsylvania and Hampton Institute in Virginia at governmental expense. Boarding schools were a means by which authorities promoted acculturation. Several of the young men in this collection of photographs appear to be wearing a form of uniform or cap (see photograph 60) and may have been just home from boarding school. The present brick school, built in 1937, includes grades from kindergarten through seventh grade. The students attend high school off the reservation in Lafayette, New York.

During this period, the greatest loss to the Onondaga, the Keepers of the Wampum, and to the Six Nations as a whole, was the acquisition of the wampum belts and strings of wampum then in Onondaga hands by the state of New York. During the splitting of the Confederacy into "two fires" following the Revolution, about half of the wampum records were taken to Canada by the pro-British Iroquois. An unknown number had been lost over the years following the Revolutionary War and the subsequent confusion and questionable sales since then accounted for more of the losses. Those lost in the 1890s were the last of the wampum records of the Great Law, treaties, and necessary ceremonies in Indian hands.

The wampum was entrusted to the Onondaga Nation by the Six Nations Confederacy and thus could have been disposed of only by the authorization of that body. This was never done. The State of New York, however, has a sizeable amount of the wampum. It is known that some of the most important wampum was obtained through the initial action of Henry Carrington, Special Agent for the 1890 Federal Census. While conducting the census in early 1891, the first federal census of the Iroquois, he gathered the usual information for the Census Bureau but included information about religious and cultural material such as the wampum and its whereabouts. He also visited each home and plotted it on a map he produced of the Onondaga Nation. Carrington, a former army general, talked the

elderly caretaker of the wampum into selling it to him. It ended up in the State Museum's collection for their "protection for posterity." However, it was not until the death of the elderly caretaker in 1897 that the loss was discovered and legal action taken to return the wampum to its rightful owner, the Iroquois people. In 1903, having pursued their suit through the courts, the Supreme Court ruled against the Onondaga Nation. In 1971, another attempt was made through the New York State legislature but it, too, failed. These wampum remain in the hands of the New York State Museum today.

Fortunately for the Iroquois people, the knowledge of the Great Law was not entirely lost, for as one door was being closed, albeit temporarily, another was opening. The Six Nations Confederacy had existed for hundreds of years since its formation without a written history of the teachings of the Peace Maker. In reciting the Great Law, the speakers relied entirely on the wampum and their memory; when the wampum began to be lost they relied on memory alone. The wampum belts are symbolic-pictograph memory aids that are used by the speaker to trigger a memorized sequence. The images recorded are the key symbols of an event or meaning to be related. The wampum strings are strung so that their colors, white and purple, encourage retrieval of the memorized sequence. In use, they are arranged in the sequence of the message. The knowledge of their individual meaning was entrusted only to key persons, though the totality of the message was known to anyone who heard the recitations. Individual references to portions of the Great Law have been recorded by non-Indians over the past centuries as far back as the 1600s.

With the loss of the wampum those that knew and cherished the messages intimately began to write it down or dictate it to someone who did. Gradually a series of manuscripts recording the Great Law, as they knew it, began to appear. In 1899, the Gibson Version by Chief John Gibson, a Canadian Seneca of the Grand River Reserve, appeared in manuscript form. In 1900, a version known as the Chiefs Version, a product of their spiritual leaders, was officially adopted by the Six Nations Council of Grand River in Ontario, Canada. In 1910, the Seth Newhouse version appeared. Seth Newhouse was a Canadian Onondaga. In 1912, Chief John Gibson dictated a revised and expanded version of the 1899 record that apparently remains untranslated. Copies of the translations were obtained by various scholars for use in their research on the Iroquois and in their publications. Of particular note is the book, *The Constitution of the Five Nations, or the Iroquois Book of the Great Law*, by Dr. Arthur C. Parker (Ga-wa-as-o-wanch or "Big Snowsnake"), who was

part Seneca. It was based on the Seth Newhouse version and also contains a version of the Hayentwatha traditions related by Baptiste Thomas (Sa-ha-whi) of the Onondaga Nation (see photograph 17). The Gai-wi-io or *The Code of Handsome Lake* was also recorded during this period.

Native Americans have always been active in sports. Historically, sports were a means to harden the young men and to instill discipline and determination for the rigors of a warrior's life. Native Americans originated lacrosse, and historically it was a favorite as it is today (see photographs 51, 56, and 57). Lacrosse or its southern variation, stick-ball, was played throughout the eastern United States with a milder variation, shinny-ball, played primarily by the women. Modern lacrosse developed from the northeastern version, however. Notice the longer handles and the longer and larger nets of the old-style sticks (see photographs 51, 56, and 57). They are more similar to a modern goalkeeper's stick. Because there were few teams off the reservation to compete with, these teams played against each other and against teams from other Iroquois reservations.

During the summer seasons of the in-between years, there was always more than one organized baseball team at Onondaga (photographs 55 and 61). They traveled throughout central New York competing with non-Indian teams and probably would be considered semiprofessional players today. A few even played professional baseball for a time.

The game of football was still an infant sport during this period but quickly became a favorite at Onondaga (see photograph 62). It is likely that the students attending boarding schools like Carlisle Indian School in Pennsylvania learned to play the game there and brought the sport home with them. Carlisle was famous for its unbeatable all-Indian football teams. Jim Thorpe was one of their star players. Several of the men on these Onondaga teams played football with him.

Judging by the uniforms and equipment used in all these sports, they were highly organized and promoted. The active involvement of Onondaga in these organized sports, primarily lacrosse, continues to the present time. Basketball was a later addition.

WORLD WAR I–WORLD WAR II

The period between World War I and World War II for the Onondaga was a time of

reconsolidation, of finding new strengths and reasserting old ones. When World War I was declared, the Six Nations, considering the United States an ally, also declared war on Germany and advised the President of their action. Many Iroquois volunteered for military service, as did Native Americans across the nation, and served as true warriors. However, Native Americans were not citizens of the United States. In 1919, a Congressional Act allowed the returning veterans to become citizens if they chose to. In 1925, the United States, through the Citizenship Act, made all Native Americans full-fledged citizens. This was done with no prior consultation with Native Americans as to whether they agreed to this or not. The Six Nations response from Onondaga was immediate. They rejected the Act and maintained that the Six Nations Iroquois were sovereign independent nations by the right and proof of their treaties with the United States.

In 1922 the Everett report was released. It was instigated by the New York State Indian Commission. David R. Hill from the Onondaga Nation was a member of this commission. The report found legal grounds for Iroquois land claims against the state of New York. The Iroquois nations had long and bitterly complained of the illegal state treaties. Through a series of hearings the commission gathered the Iroquois opinions in addition to legal consultation and research. Onondaga Chief George Thomas and Jaris Pierce, Onondaga (see photographs 52 and 61), gave testimony. The commission's findings were completely rejected by the state. The report, however, led to the first of a series of land claims by the Iroquois nations in the courts against New York State.

The Great Depression brought economic hardships throughout the United States but was felt even more among the already struggling people of the Six Nations. The federal programs of the New Deal, administered through various federal and state agencies, brought economic relief to these communities and spawned a cultural revival among Native Americans throughout the country. The impetus for these programs came from John Collier, Commissioner of Indian Affairs, who insisted on traditional culture-based programs for Native Americans. With the assistance of concerned anthropologists and like-minded administrators, the programs became a landmark resource of Iroquois culture that continues to have its effects today.

In the Onondaga Nation these programs produced many public works projects such as the construction of a youth center through the National Youth Administration (NYA). They made land and highway improvements. In addition, vocational training and culture classes were taught by people within the com-

munity. Chief Jessie Lyons (see photograph 4) taught Onondaga youth about their cultural heritage. Among other subjects available were classes in photography, furniture repair, chair making, book binding, log cabin construction, as well as a wide variety of traditional crafts. The construction of the NYA building alone enabled many, in cooperation with the local carpenters union, to learn carpentry and gain a trade. The Onondaga were fortunate in having Louis R. Bruce, Jr., a Mohawk-Sioux, as the NYA's statewide supervisor of Indian programs. Bruce grew up in the Onondaga Nation and later went on to become Commissioner of Indian Affairs. Between 1936 and 1939 he designed twenty-six ongoing work projects and employed hundreds of Iroquois youth, many of them Onondaga. One of the most successful was a camp counselor program, in cooperation with the American Camp Association. This program provided training during the winter months and a job as a camp counselor during the summer months in youth camps throughout the Northeast where the young Indians shared their cultural heritage. But the beginning of World War II and the elimination of federal funds brought the programs to an end.

During the Second World War the Six Nations Confederacy, to demonstrate their independence and their solidarity with the United States as an ally, also declared war on the Axis powers. Many Iroquois volunteered for military service. However, the Selective Service Act caused many traditionally minded Iroquois to reject the authority of the United States to draft members of another nation. They maintained in the courts the sovereignty of the Iroquois Six Nations as acknowledged by United States treaties. For insisting that their rights as Iroquois be recognized they suffered resentment, persecution, and rejection from both Americans and other Iroquois.

IROQUOIS STANDOFF

The period from the end of the Second World War to 1974 was one of growing confrontation with federal and New York State officials. Even a brief study of the record of any of the events indicates that these confrontations were very lopsided, with the Six Nations resisting an action taken against them. In the land claims suits, they had just cause to attempt to right a wrong committed against them. The roots of this period's problems reach back over the past century and are to be found

whenever federal and state authorities passed legislation that was deemed good for Native Americans even though Native Americans did not agree. Often they were not even consulted. During the prior three decades, the Onondaga Nation had been learning and sharpening its legal skills even though it had been unable to effect any change in its battles.

In 1948, the state of New York, in collusion with the federal government, passed legislation in which the United States gave legal jurisdiction over Native Americans whose reservation lay within the boundaries of the state to the state of New York. During hearings prior to passage, Indian people throughout the state had voiced their opposition to the legislation based on their sovereign status as independent nations as guaranteed by federal treaties. They wanted to remain under federal jurisdiction.

In the years that followed, although still opposing the illegal action, some of the individual Iroquois nations accepted the legislation or some modified form of it. The Onondaga Nation has refused to recognize the legislation. But by working closely with local authorities over the years, the Onondaga have worked out an agreement. The Council of Chiefs is responsible for their own jurisdiction, and it deals with all infractions. It allows state or county legal action for major crimes but only with its consent.

In 1968, the state highway department attempted to confiscate, without approval of the Onondaga Nation, additional land to widen the off-ramp of Interstate Highway 81 that crosses the southeastern corner of the Onondaga Nation. The Onondaga people responded by physically blocking and preventing the heavy equipment from starting any work. The state was forced to rescind its expansion plans. A federal court found that the state did not have the power of eminent domain and must cease its attempt to confiscate land from the Onondaga Nation.

Although not directly involved, the Onondaga Nation, during this period, gave its support to other Iroquois nations against federal and state authorities. Such legal battles included the confiscation of land from the Tuscarora Nation by the New York State Power Authority for a power reservoir in 1958 and the construction of Kinzua Dam on the Allegheny Seneca Reservation in 1959. The Onondaga Nation also gave its support to the Mohawk people at Ganienkeh in 1974 when they forced the return of some of the illegally taken Mohawk territory. They also gave moral support and sent a delegation to the Oglala Sioux Nation during the Wounded Knee II incident in 1973 in South Dakota.

CONCLUSION

During the in-between years the Onondaga people suffered the greatest losses of important physical expressions of their culture such as the wampum and cultural objects, but they resolutely retained the spiritual essence of their own identity. It is difficult to understand today why, through whatever means, these irreplaceable things were allowed to be lost to the future Onondaga. However, at each loss, the belief that there would be no one to care for these important things in the future was often expressed, even by the Onondaga themselves. In considering the situation and direction of their people at the time, they reluctantly parted with them, sincerely feeling that they would at least be cared for. Tragically, this seems to have been the general feeling of many during the in-between years. It was a period of seemingly uncontrollable pressures, a time of surviving and waiting to see what would happen, waiting to see if there would be a future.

Fortunately, there were those who were strong and maintained their culture and beliefs. Those who doubted that there would be a future have been proven wrong. They are still here and are stronger in their determination to survive as a people. However, the concerns of those who waivered should not be taken lightly, for they, too, realized the value of their culture and thought that they were doing the best they could at the time. The mistakes of the past must be knowledge for the present and the future if they are not to be repeated, for those pressures from the outside world are still there and stronger than ever before and now include the technological wonders of today's world. These things are not wrong in themselves. They are part of the world that the Onondaga must live in and can benefit from. They must strive, as the Onondaga at the turn of the century did, to reclaim that which is part of them, selecting from the modern world that which can be of use and yet stoutly retain that which they have found to be uniquely theirs.

The photographs included in this book are an eloquent reflection of the acculturation the Onondaga struggled with during the in-between years.

The Photographs

FRED R. WOLCOTT

THE PEOPLE: *Faces of a Nation*

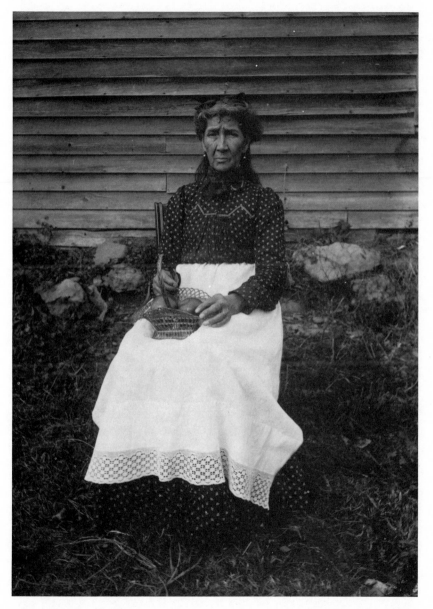

1. Mary Jones. c. 1905

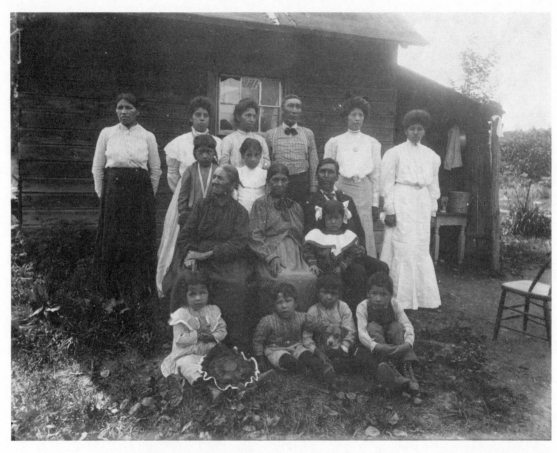

2. A backyard gathering on the Onondaga Reservation at the turn of the century. Among those identified are Thomas LaFort, seated on the right; Daniel Hill, standing in the middle; and Libbie Johnson Homer, the child standing on the left. LaFort was the minister at the Wesleyan Methodist Church on the reservation, and Hill listed himself as a "wheelwright" in a wagon shop for the 1910 census. c. 1905

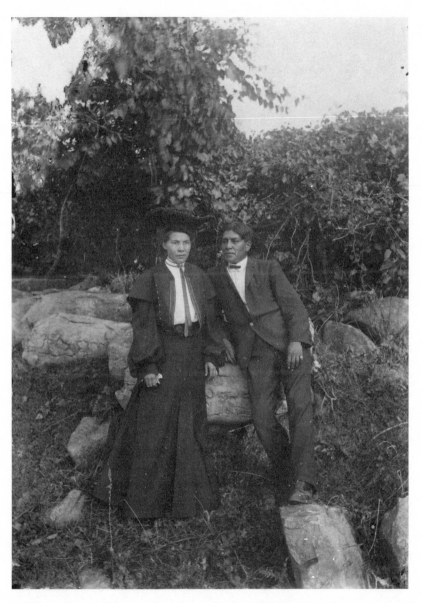

3. Hiram Jones (Ha-wen-daw-na-wenh or "Mild Day") with an unidentified woman.

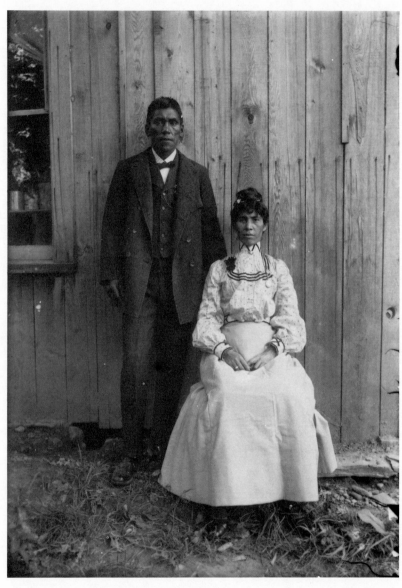

4. Jesse Lyons, a laborer in a saw mill, and his wife, Julia. Lyons was also an active member of the reservation lacrosse team. c. 1905

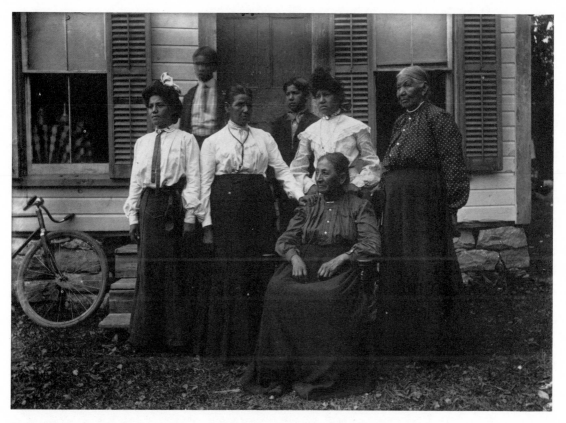

5. Gathering at the Pierce home, possibly upon returning from church. Seated: Lucy Pierce; first row: Lilly Big Knife, Melinda Jacobs, Eleanor Jacobs, and an unidentified woman; second row: Leonard and Ernest Jacobs. c. 1905

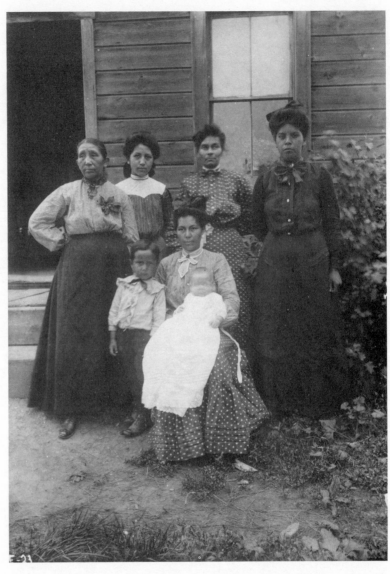

6. Front row: Amos Jones; Edna Jones; and Maggie White Tarbell; back row: Emily Honyoust (Wa-dwanh-nee-nay); Lilly Green, mother of Helen Crouse; Cecelia White, Mohawk (?); and Lydia Webster Steep Rock. c. 1910

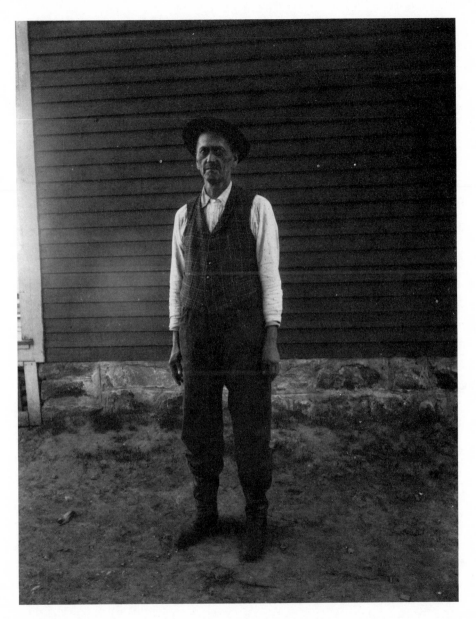

7. Webster (?).

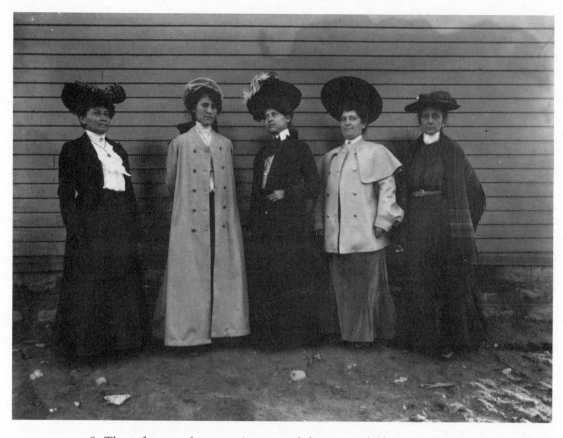

8. The influence of current American fashions, available in nearby Syracuse, is clearly evident in this photo. Left to right: Hattie George, Nancy Chubb, two unidentified women, and a woman believed to be Maggie Thomas. c. 1905

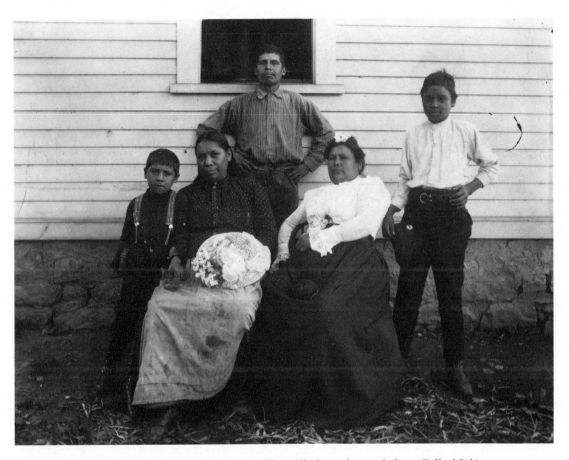

9. Front row: Wilson Johnson, Molly Johnson, Nellie Hill (Say-gah-naw-hah or "Full of Oil/ Grease"), Patsy Johnson; second row: unidentified. c. 1910

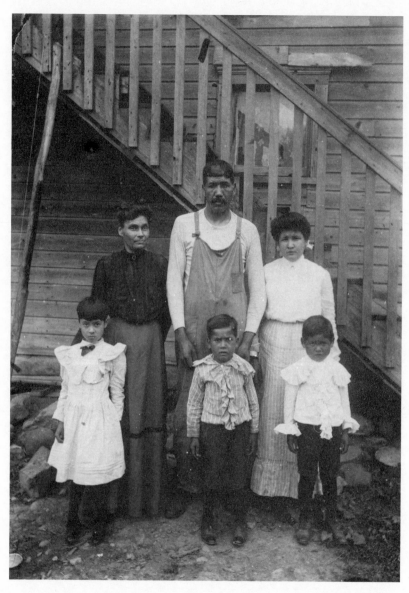

10. John Ninham with Cecelia White on the left and his daughter, Molly, on the right. The children are unidentified. c. 1905

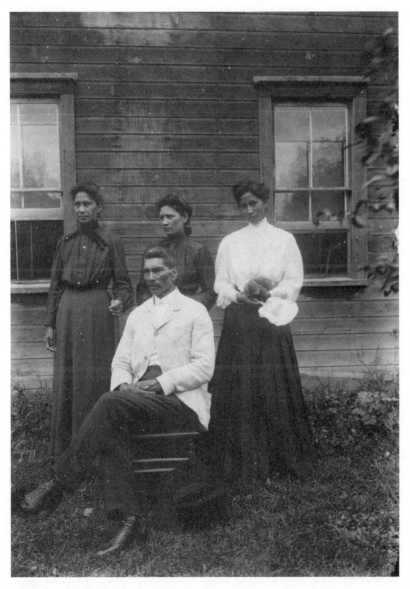

11. The Dan George family. Seated: Dan George; standing: Susan Crouse; Ida Williams, mother of Dorothy Williams; Lucinda Crouse. The three women are sisters. c. 1910

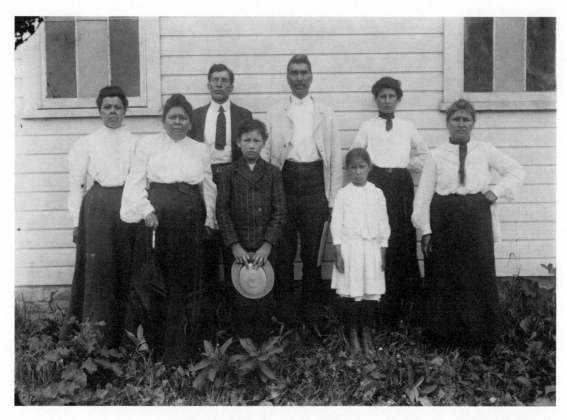

12. George family beside the Wesleyan Methodist Church. First row, left to right: Maggie George, wife of Henry George; Phoebe George, wife of Dan George; Carl George; Iva George; unidentified woman; second row: Henry George, a lay minister of the Wesleyan Methodist Church and brother of Dan George; Dan George, uncle of Dorothy Williams; Ida George, niece of Phoebe George. c. 1910

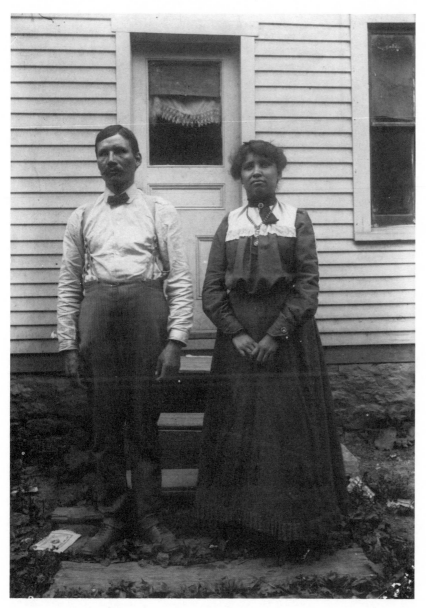

13. Unknown individuals.

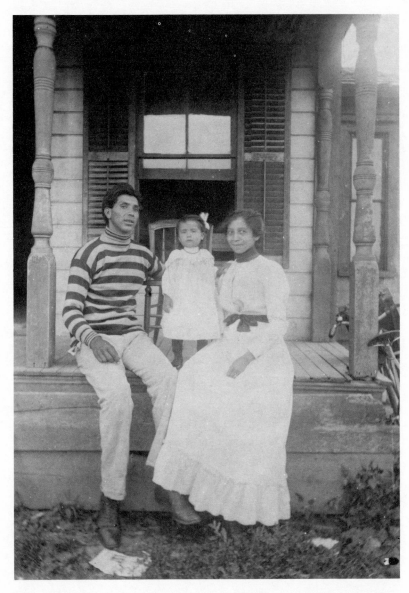

14. Baptiste Lyons, wearing a jersey of the reservation football team, with his daughter, Rita, and wife, Clara. c. 1905

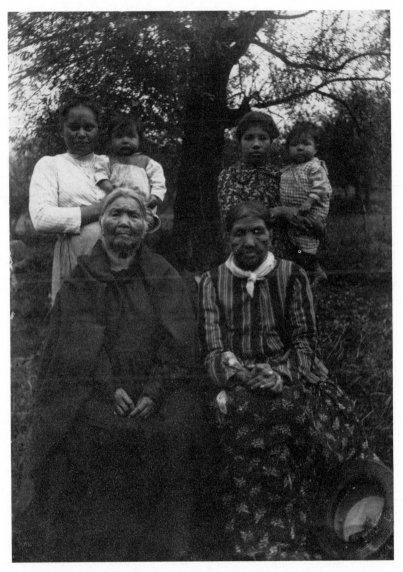

15. An original of this print was labeled, "The Oldest and the Youngest on the Reserva-
tion." Eddi Logan is on the right holding her child and standing behind her grandmother,
Emma Logan. Those on the left are unidentified. c. 1905

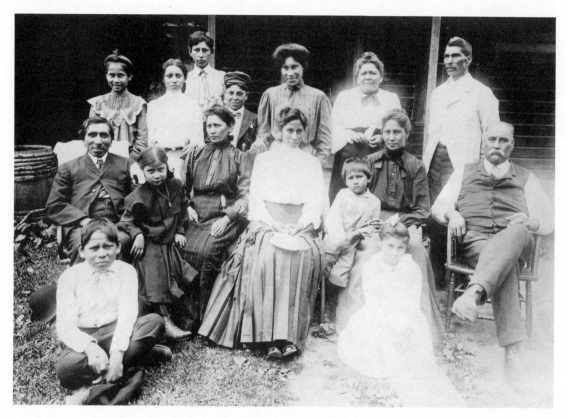

16. Among those pictured and identified in this large gathering on the Onondaga Reservation are the three seated women (from left) Ida Williams, Lucinda Crouse, and Susan Crouse. Dan George, in the white coat, is standing behind Jaris Pierce, seated at right. Standing to George's right is his wife Maggie. c. 1910. *Courtesy of the Onondaga Historical Association*

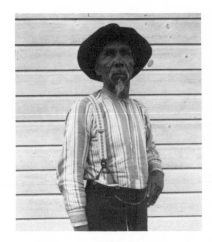

17. Baptiste Thomas (Sa-ha-whi) was married to Emma LaFort. A translation of the Hiawatha tradition by him is included in the book, *The Constitution of the Five Nations*, by Dr. Arthur C. Parker. The date of this photograph, January 31, 1916, is provided courtesy of the Onondaga Historical Association, which also has a print in its collection.

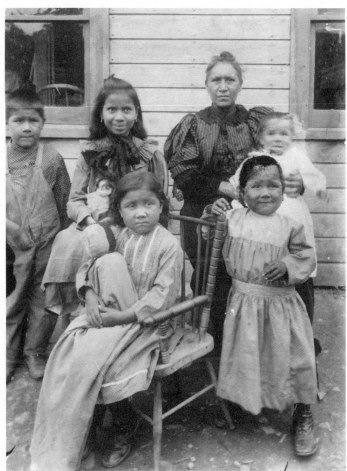

18. Victoria Gibson and her children. c. 1905

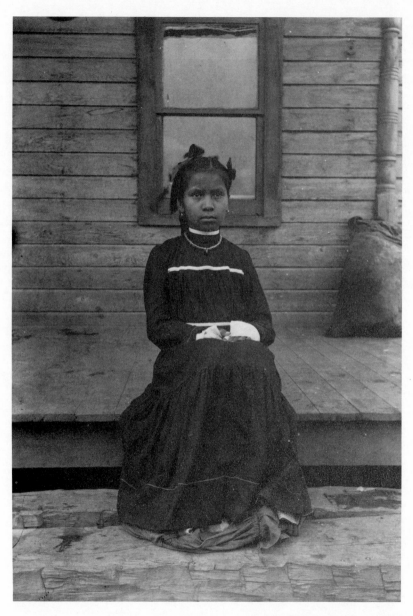

19. Unidentified girl. c. 1905

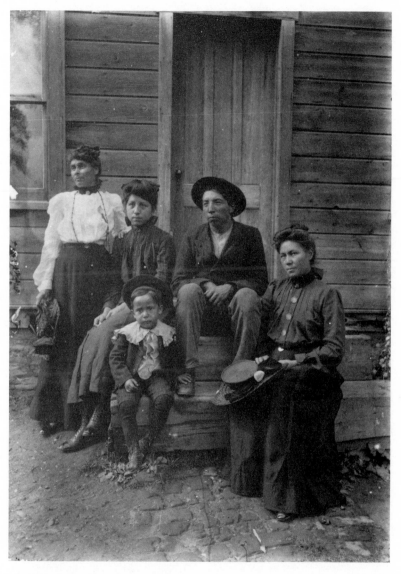

20. Eddie Jones was a laborer in Solvay, New York. His half-sister, Lilly Green, who worked as a housekeeper, is seated on the left. Cecelia and Maggie White are at the far left and right, respectively. The little boy is Amos Jones. c. 1905

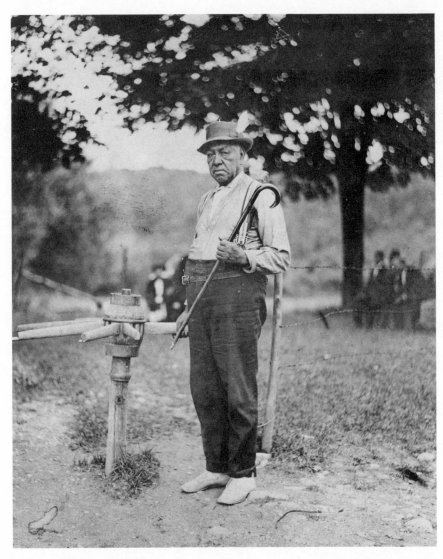

21. Harry Isaacs (Ha-han-gwus) at a Condolence Ceremony. On the back of the original print is written: "Harry Issacs at condolence Sept. 8, 1917. Not a chief, as so often called but a fine specimen of his family. The revolving gate is a wagon wheel minus the felloes."

Courtesy of the Onondaga Historical Association

THE RESERVATION: *Images of Home*

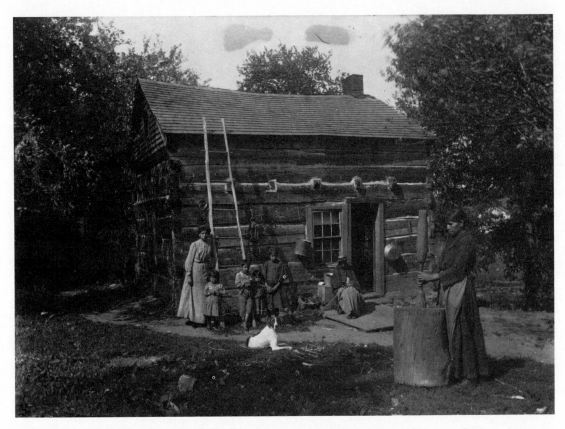

22. The home of Frank Logan and his family. Hewn timber cabins were becoming rare on the reservation even in Wolcott's time. A few, however, still remain today. The style was borrowed from the English colonists and represents the earliest form of housing used on the reservation following its establishment in the late 1780s. c. 1905

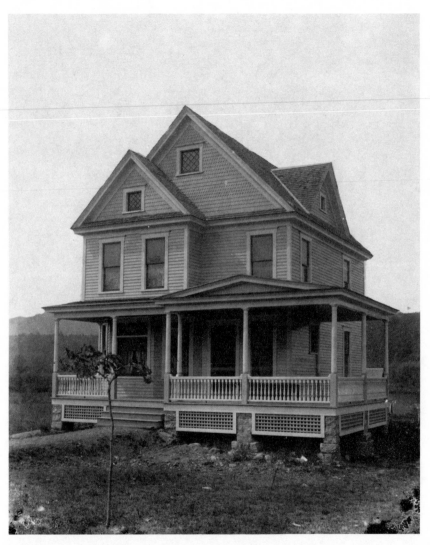

23. The home of David R. Hill, an 1895 graduate of Virginia's Hampton Institute, who turned his musical talents to become the manager of the reservation's cornet band (photograph 59). The house is still standing on the reservation as of 1985. Probably built in the late 1890s, this house is similar to many homes erected in nearby Syracuse at the turn of the century.

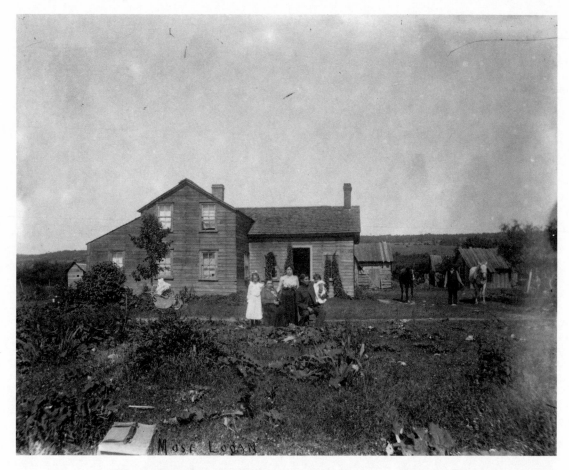

MOSE LOGAN

24. The Beckman homestead represents a typical reservation farm of the period, complete with the usual assortment of barns and outbuildings. Lucien Beckman is standing near his two horses. His daughter, Lilly, and her husband, Mose Logan, are seated in front. Standing, left to right, are Lilly's sisters: Molly Beckman and Harriet Beckman. The child is an unidentified Logan. Note that Wolcott's camera bag was captured in the image's foreground. c. 1905

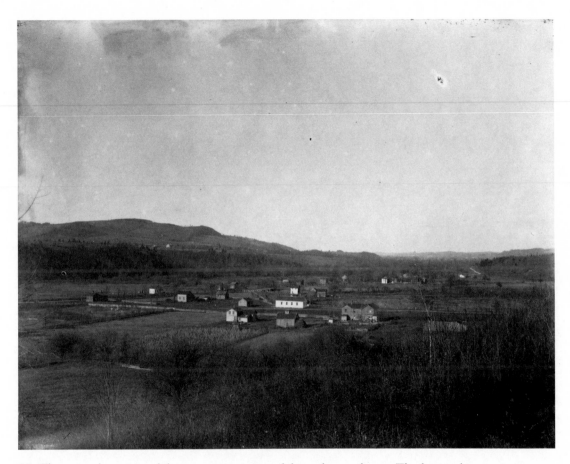

25. The central portion of the reservation, viewed from the southeast. The long, white Council House is clearly visible. The massing on the horizon at right center is Crouse College on the Syracuse University campus. The majority of homes dates from the mid-nineteenth century. The simple, vernacular style of these farmhouses was common throughout rural upstate New York. c. 1905

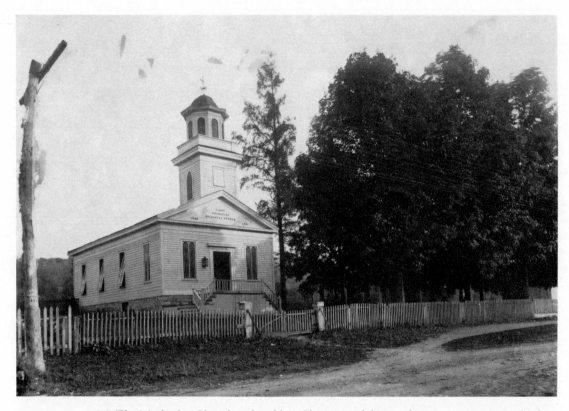

26. The Methodist Church is the oldest Christian edifice on the reservation. It was built in 1848 and displays a Greek Revival form typical of the time. Remodeled in 1885, it stands opposite the school. Missionaries have worked among the Onondaga from the time of the Jesuits' first visit in 1654. In Wolcott's day about half of the reservation's five hundred residents were reported to be Christian. c. 1915

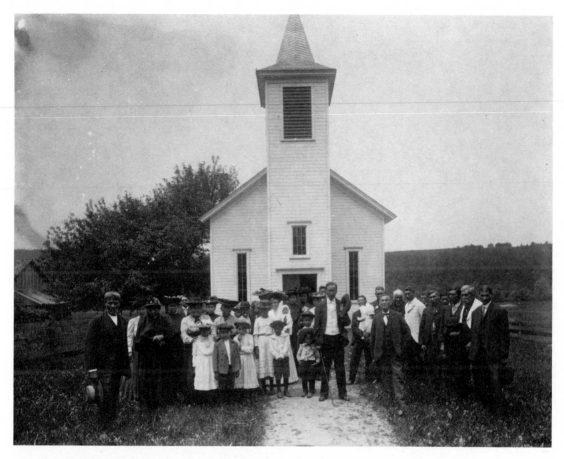

27. The Wesleyan church was built in 1895. Wolcott posed its founder and minister, Reverend Thomas LaFort, as the central figure. LaFort's brother, Daniel, was an Onondaga chief and a Traditionalist. The Longhouse and Christian religions have coexisted on the reservation, but the latter has been a force for acculturation. c. 1910

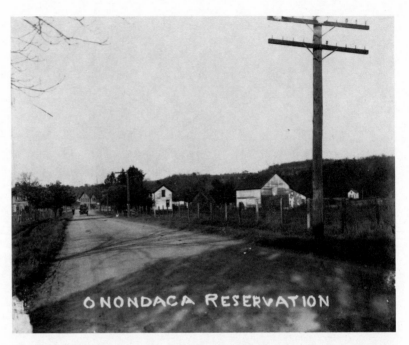

ONONDAGA RESERVATION

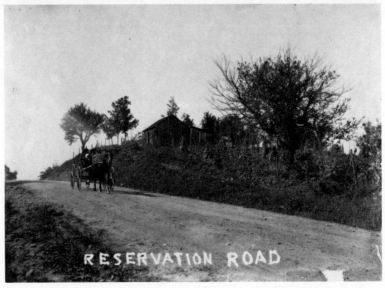

RESERVATION ROAD

62

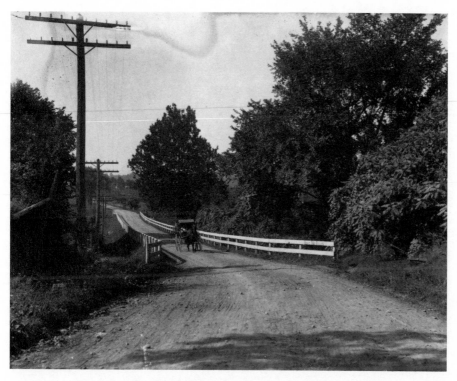

30. View of Highway 11A, Onondaga Nation, below the hill from Nedrow. c. 1910

28. (Left, top) View of the north entrance, Highway 11A, to the Onondaga Nation. The town of Nedrow is in the distance at the end of the road. c. 1910

29. (Left, bottom) View of Webster's Hill, Highway 11A, Onondaga Nation, from the north side coming from Nedrow. c. 1910

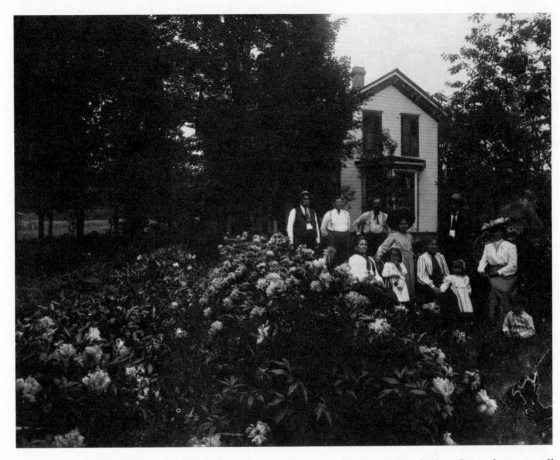

31. A structure that exhibits Victorian detailing of about 1880, the Jaris Pierce home is still standing on the reservation today. Pierce, at the far left wearing a vest, was a successful farmer. The flowering peonies were a popular planting of the day and indicate that the photograph was taken in late spring. The "rustic" chair on the right was probably crafted on the reservation. c. 1905

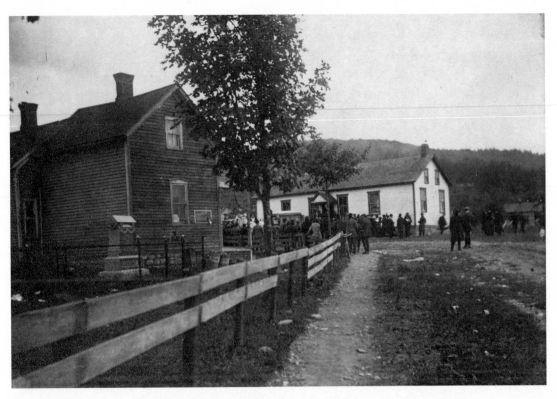

32. View of the Onondaga Council House during a funeral, possibly in September 1917, when Wolcott also photographed the Condolence Ceremony at the time of a chief's death.

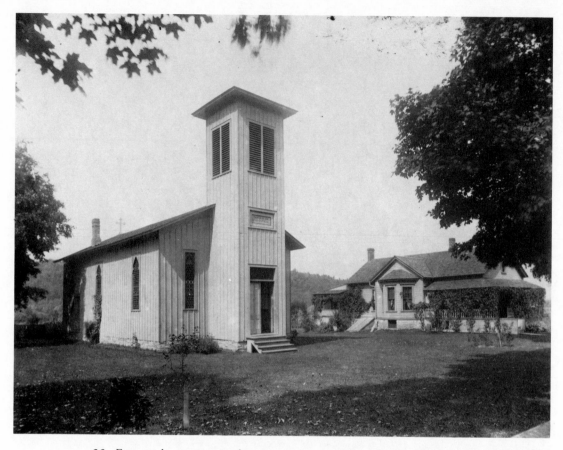

33. Episcopal activity on the reservation dates from 1816. The Church of the Good Shepherd was built several decades later with vertical board-and-batten siding. It still stands today. c. 1915

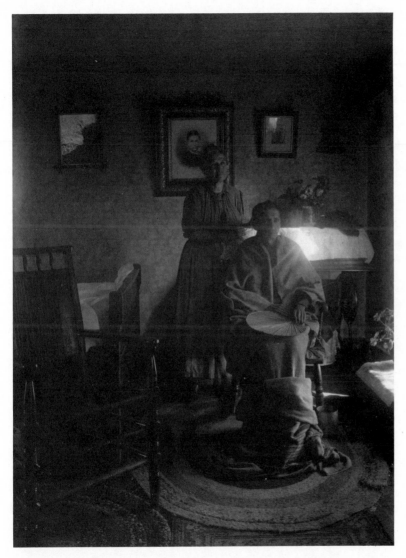

34. For the only interior image in the entire Wolcott collection, the photographer used available light from the nearby window to pose Phoebe Jones and her son, Joshua. Joshua was suffering from tuberculosis at the time. The Christmas wall decoration on the right is dated 1904, and the furnishings are typical for this period. c. 1905

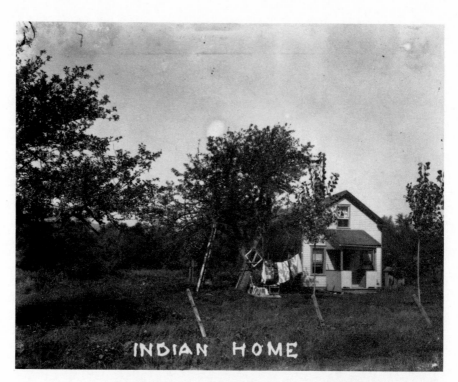

INDIAN HOME

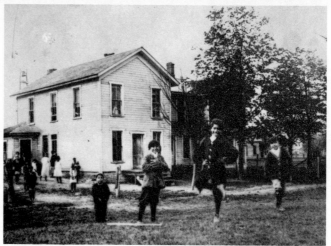

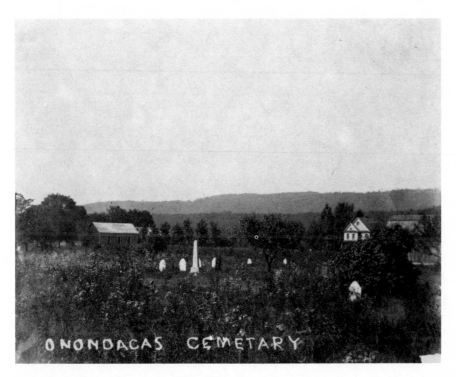

37. Onondaga Indian Nation Cemetery across Hemlock Road from the Council House. c. 1910

35. (Left, top) Onondaga home, circa early 1900s. This home was later occupied by Nick and Susan Thomas and family. c. 1910

36. (Left, bottom) Suicide Inn (Jake's Hall). This building was used temporarily as a school. c. 1910

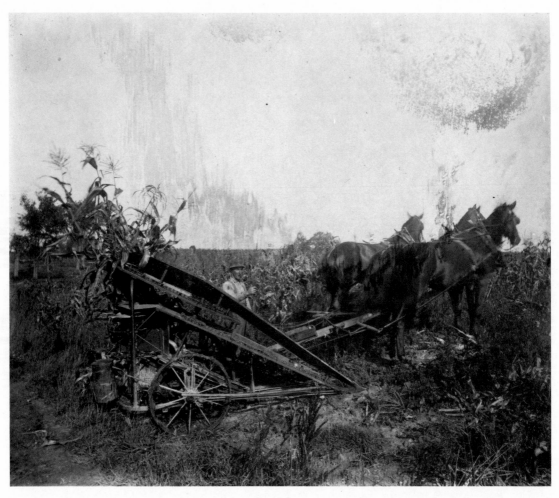

38. Corn harvesting machine on the reservation. c. 1905

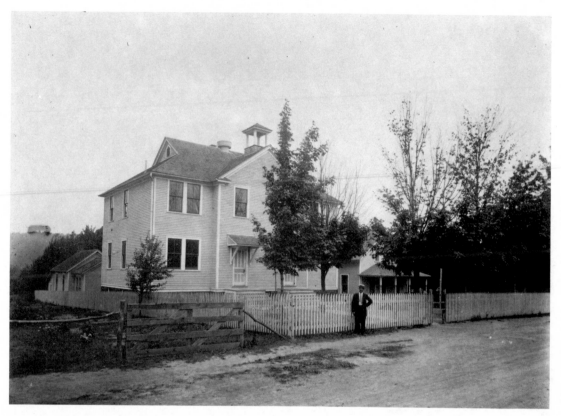

39. This state-financed school was completed in 1915. It was built on the foundations of the first state school, which burned in 1913 after twenty-six years of use. Many older residents of today's reservation began or completed their education here. In 1937, it too was lost to fire and replaced by the present brick structure. Originally, the state school provided both elementary and high school classes. Today, it has evolved into a facility for kindergarten through seventh grade. Upper-level instruction is provided by the Lafayette School District. c. 1915

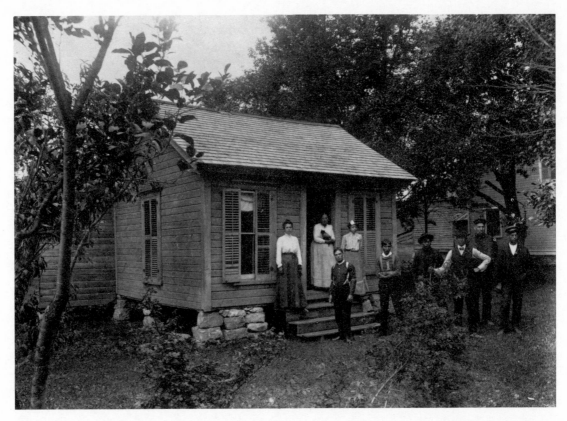

40. This house, believed to be the Andrew Pierce home, is also visible in photograph 5. A more modest home than that of Jaris Pierce, its scale followed that of the early nineteenth-century reservation log cabins from which it evolved. c. 1905

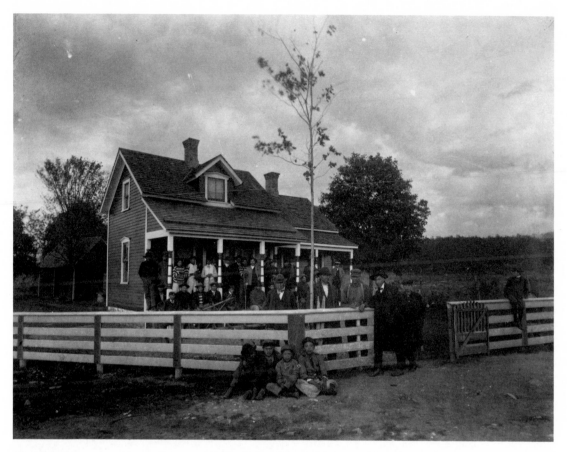

41. This home is a short distance north of the Council House. The photograph was apparently taken just after a lacrosse game, which was usually played in a nearby field. c. 1905

THE "AMERICAN" INDIAN: *View of the Outsider*

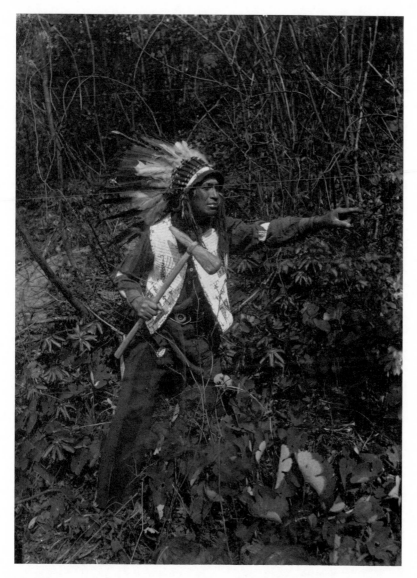

42. Adam Jones (Taw-nenh-doe-wenhs or "He splits the hemlocks"). The pose with mock war club, plus the use of Western Indian style headdress and beaded vest typify period stereotypes. c. 1910

75

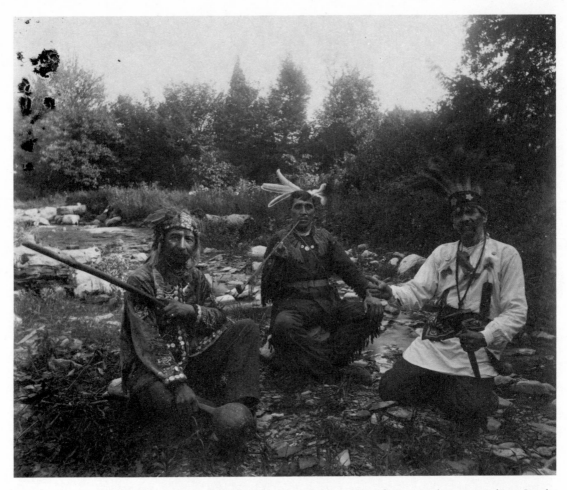

43. Hewlett (?) Jacobs, Charles Green, and Albert Cusick in special-occasion dress. Jacobs is holding a gourd rattle and wearing the traditional Iroquois headdress, a ga-sto-we. Green, a chief, holds a ceremonial Council pipe. Cusick, posed with a metal tomahawk, was a former warrior chief of the Six Nations. By 1896, he had renounced his position and become the minister for the reservation's Episcopal church. c. 1910

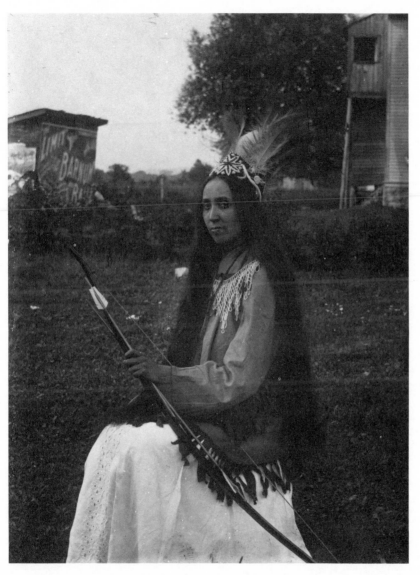

44. Unidentified woman wearing a Western-style man's cloth shirt with a beaded necklace and an Iroquois headdress of the period. The bow and arrows she is holding show Western Indian dress influence. c. 1910

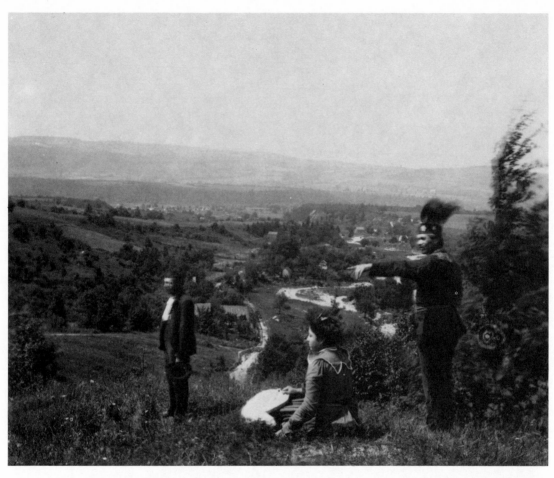

45. Upper Hemlock Road area of the Onondaga Nation. Unidentified, Melinda Johnson, and Albert Cusick. c. 1902

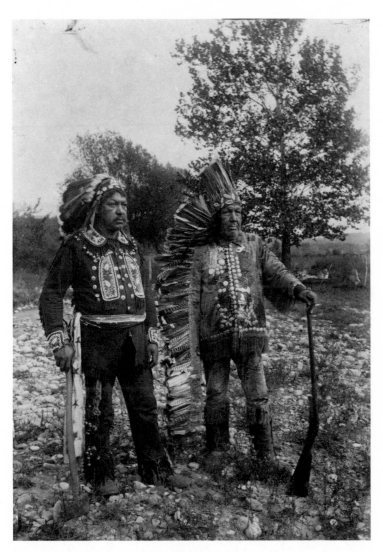

46. Harry Isaacs and his uncle, Bill Isaacs. Both are wearing their special-occasion Iroquois dress. The leather shirt decorated with traditional beadwork evolved from a colonial military tunic. Adding metal pins and brooches to clothing was popular among the Iroquois as early as the eighteenth century. Both featured headdresses show strong influence from Western Indian culture. c. 1905

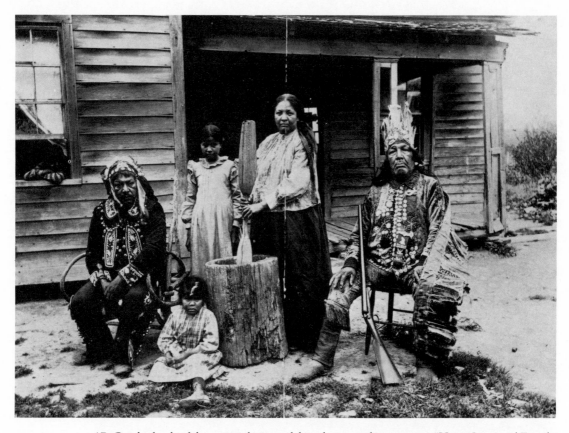

47. On the back of the original print of this photograph is written: "Harry Issac and Family in front of his home and uncle Bill Issac with gun. All dressed up for the camera man. Mrs. Issac was pounding corn for a Johnny cake. Harry and Bill on each side of her. Several families on the Onondaga Reservation still use this method of grinding this indian corn for meal. F. R. Wolcott." c. 1905. *Courtesy of the Onondaga Historical Association*

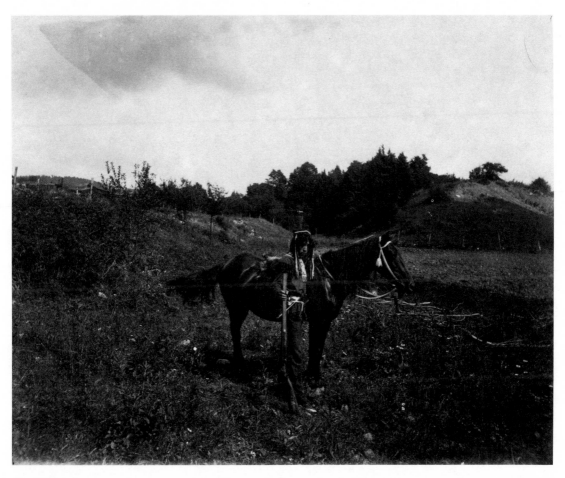

48. Will Johnson, a farmer, posed in Western Indian style clothing with a percussion musket. c. 1910

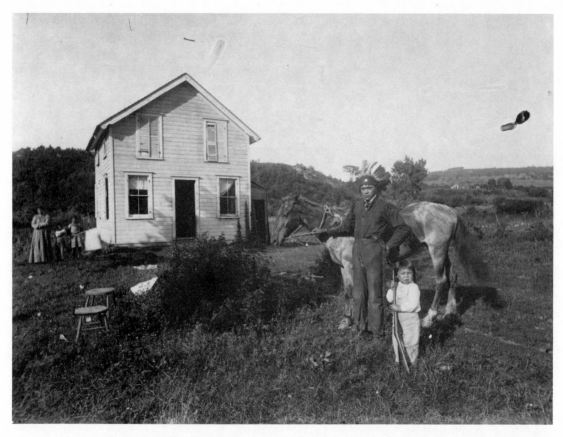

49. Newton Green and family in a posed photograph in front of Green's mother's home. He is wearing Western Indian style clothing made of fabric and Western-style feathered headdress. Note that the shirt is worn over a white shirt, sweater, and tie. The costume, gun, and pistol are probably props owned by the photographer. c. 1910

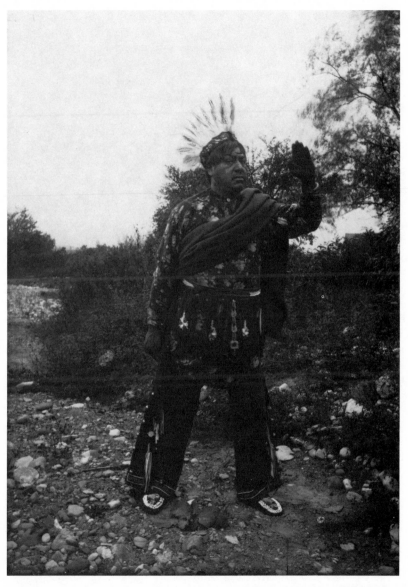

50. Harry Isaacs listed his occupation in the 1910 census as a maker of "rustic chairs."
c. 1905

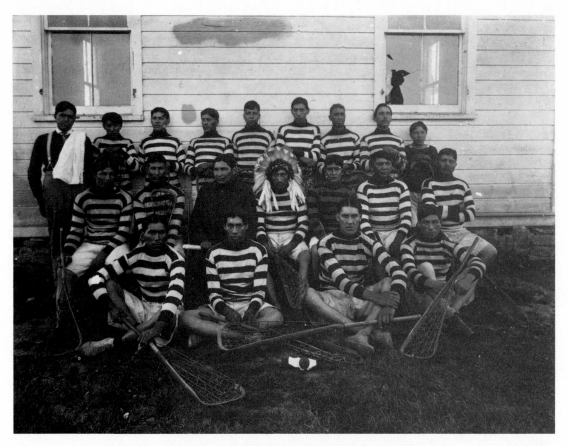

51. The Onondaga lacrosse team. This sport originated with Native Americans and has remained popular with the Onondaga to the present day. Lacrosse is a rough game in which teams use their sticks to throw or carry a small ball between their opponent's goal posts. The lacrosse sticks seen here are of the traditional style. The longer nets distinguish them from the modern adaptation. Front row, left to right: Jesse Lyons; Eddie Logan (?); Ike Lyons; David Torrence (?); second row: Howard Hill (?); Ulie Pierce (?); Mose Logan, team manager, who also held that position for baseball and football at the time; unidentified; Sidney Logan; Eddie Thomas; unidentified; back row: Newton Green, assistant manager (?); unidentified; unidentified; unidentified; Adam Thomas; unidentified; Adam Jones; Bill Beckman; John Isaacs. c. 1905

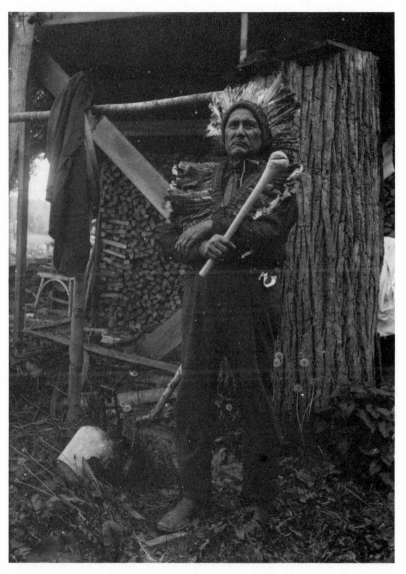

52. Jaris Pierce, a farmer, stands near a smokehouse. He is wearing a Plains Indian headdress and carries a mock Iroquois war club. In 1882, Pierce was involved with unsuccessful attempts to form a constitutional government on the reservation. c. 1905

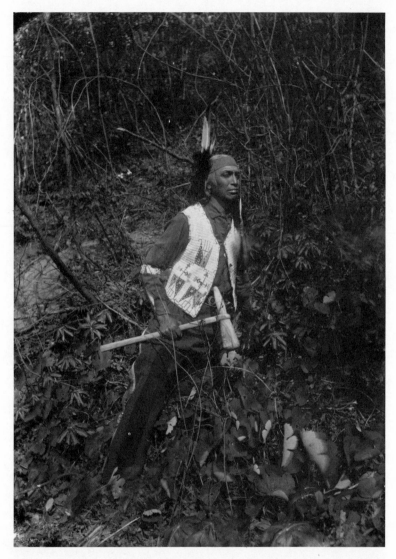

53. Adam Jones posed in Western Indian dress in a costume probably from the photographer's collection. Jones's disposition was the origin of the modern Onondaga term "He got Adam," a way of saying "He became obstinate" or "He began to pout and became quiet just like Adam." Jones also posed for a sculpted bust in the New York State Museum. c. 1910

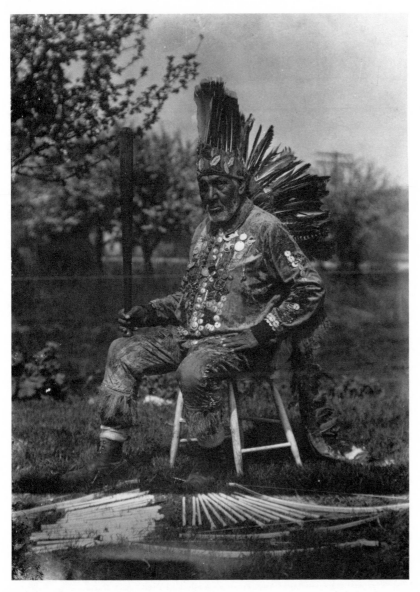

54. Bill Isaacs wearing his special-occasion Iroquois dress of the period. The feathered headdress with trailer shows Western Indian dress influence. c. 1915

THE PASTIMES: *Spirit of Camaraderie*

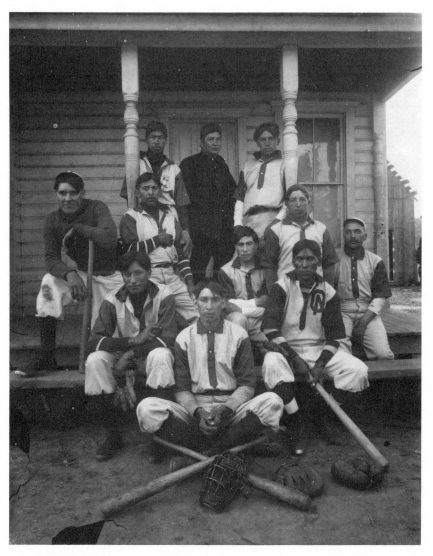

55. The Onondaga Nation baseball team in a pose reminiscent of any turn-of-the-century American town team. Foreground: Emmett Lyons; first row, seated on steps: unidentified, left; Jesse Lyons, right; second row: Ike Lyons; Alec Jones; David Torrence (?); Eddie Jones; Bill Beckman; standing: Elmer Printup; Mose Logan, team manager; unidentified. c. 1905

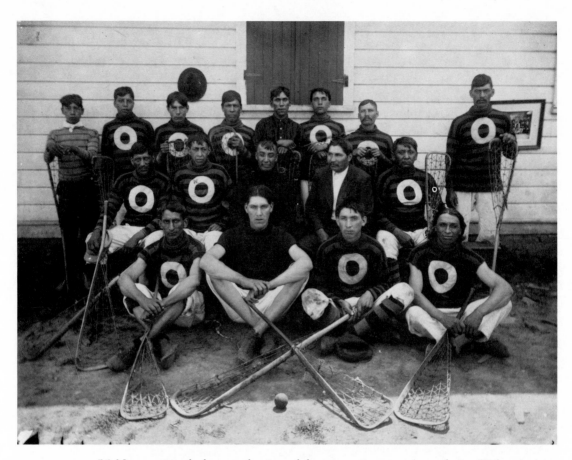

56. Not surprisingly, lacrosse dominated the reservation sport scene during Wolcott's visits. Highly organized, the Onondaga team often competed with those from other reservations. It is a game in which teamwork and running skills are essential. Front row, left to right: Joshua Scanandoah; Ike Lyons; Emmett Lyons; Adam Jones; second row: unidentified; unidentified; Eli Scanandoah; Mose Logan, team manager; Sidney Isaac; back row: unidentified; Adam Thomas; unidentified; unidentified; Jesse Lyons; unidentified; Bill Beckman; unidentified. c. 1902

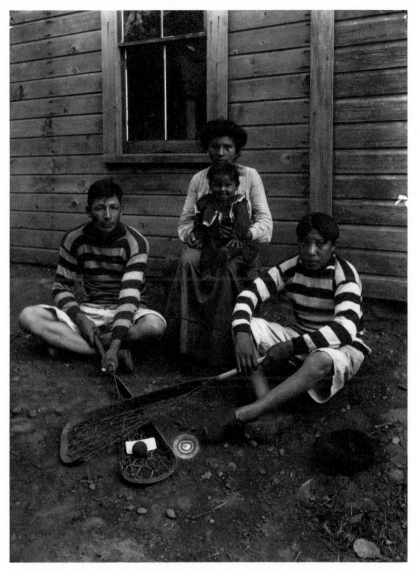

57. From left: Howard Hill (?) (Gae-gwa-e) (?); unidentified; John Isaacs (Tie-whan-duts), brother of Elsie Logan. Wolcott's advertisement card can be seen on the lacrosse stick. c. 1910

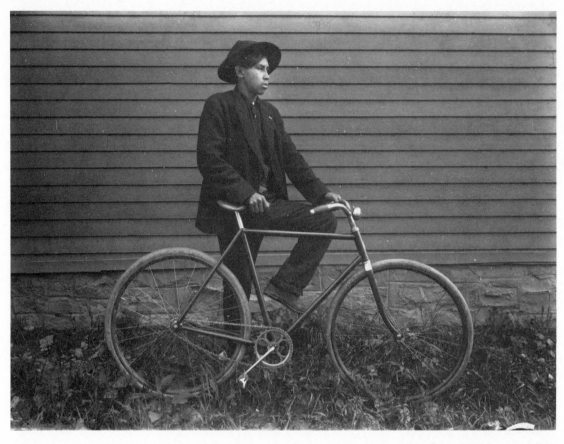

58. George Webster. c. 1905

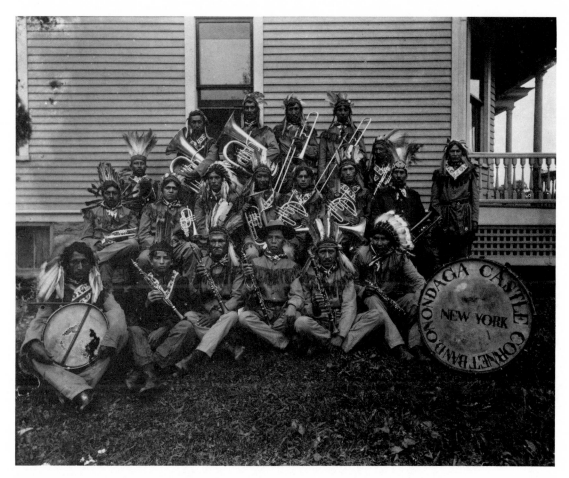

59. An 1896 county history called the Onondaga Castle Cornet Band "perhaps the best-known organization among the Indians." Formed in 1862, it had played throughout the state by the end of the nineteenth century. This included an appearance in Onondaga County's centennial parade on June 6, 1894. First row, left to right: Joshua Scanandoah, Owen Jones, Simon Scanandoah, Elmer Jacobs, Charles Green, Mose Logan; Second row: unidentified, Newton Green, unidentified, unidentified, Nelson Jones, Eugene Jones, remainder unidentified; third row: the taller man in front of the window is Dan George. c. 1910

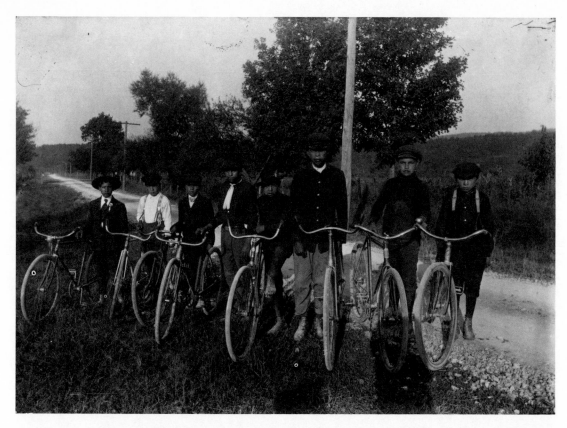

60. Bicycles became very popular throughout turn-of-the-century America. The reservation, it appears, was no exception. Several of Wolcott's photographs demonstrate the bicycle's value to the adolescent Onondaga boys. The similarity of clothing in this image could indicate they were traveling to or from the school. c. 1905

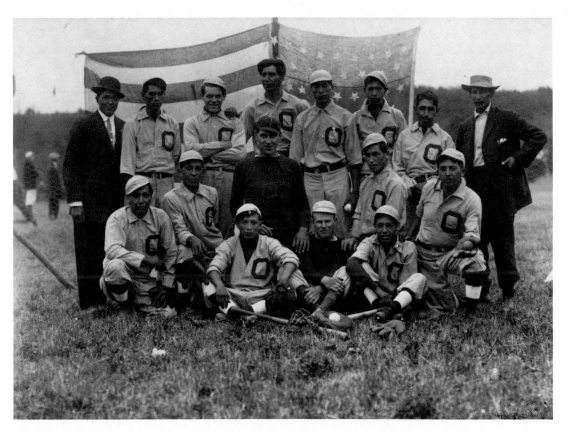

61. The early twentieth-century baseball teams at Onondaga traveled throughout central New York to compete with non-native clubs. Occasionally, non-Indian players joined the Onondaga teams as well. The level of play might be compared to semiprofessional ball today. A few players even rose to professional league status for a time. Front row, seated: Daniel Hill; one of two unidentified non-Indian brothers who played with the Onondagas; Harrison Farmer; second row, kneeling: Eli Schendoah; Carl George (?); Ike Lyons; David Torrence; Alec Jones; back row: Newton Green, assistant manager (?); John Webster; unidentified non-Indian; Baptiste Lyons; George H. Thomas, who became Tohdadaho in the 1920s; Frank Isaac; Welcome Powless; Ulie Pierce. c. 1915

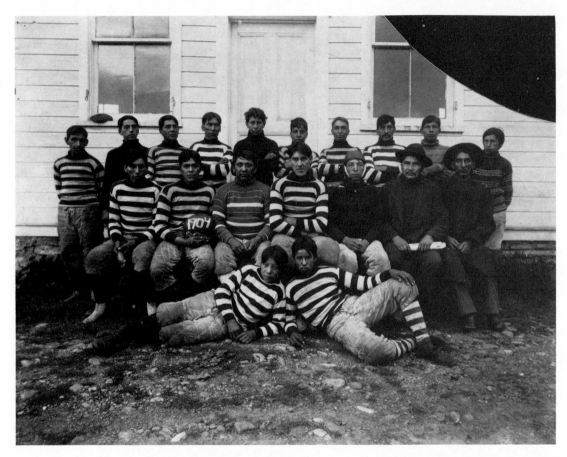

62. Football was still an infant sport during this period but quickly became a favorite at Onondaga. It is probable that Onondagas attending boarding schools in places like Carlisle, Pennsylvania, brought the game home with them. At least one member of this Onondaga team, Ike Lyons, played football with Jim Thorpe at Carlisle. Reclining: John Isaacs, left; Leonard Jacobs (?), right; front row: unidentified; Newton Green; Sidney Isaacs, Ike Lyons; Eddie Jones; Mose Logan, team manager; Joshua Scanandoah, assistant team manager (?); back row: Welcome Powless; unidentified; Hiram Jones; Jesse Lyons; unidentified; Adam Thomas; Adam Jones; unidentified; unidentified; unidentified. c. 1904

63. Unidentified, left; Eddie Logan, right. c. 1905

THE TRADITIONS: *Signatures of a People*

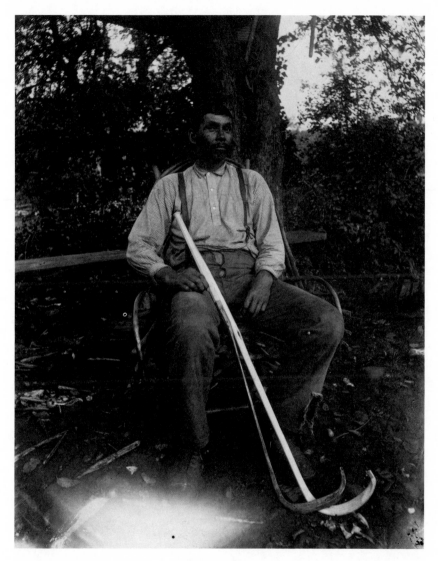

64. Frank Logan was the principal Onondaga chief at the time of this photograph. As was custom, this also made him Tohdadaho. The bentwood-style "rustic" chair and the lacrosse sticks were commonly made in this period at Onondaga and represent distinctive craft traditions. c. 1905

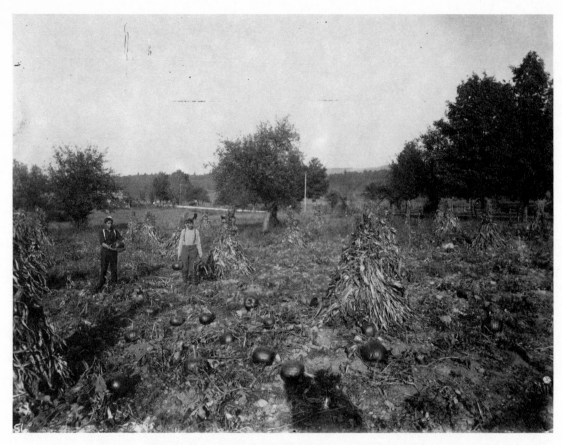

65. Agriculture has always been a key element of Onondaga culture. The corn and pumpkins clearly visible here are traditional crops that were common during the period of Wolcott's visits. Will Johnson, one of the many farmers at the time, is on the left. c. 1905

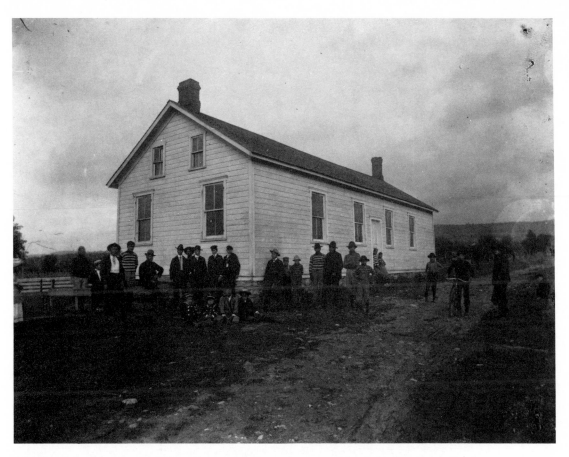

66. The Onondaga Council House has always been the central focus for the spiritual and political concerns of the Confederacy. Although of frame construction by 1900, its long, rectangular shape and east-west orientation are unmistakable traditions. This building, today more than 110 years old, exists at Onondaga side by side with the new, enlarged Council House. c. 1905

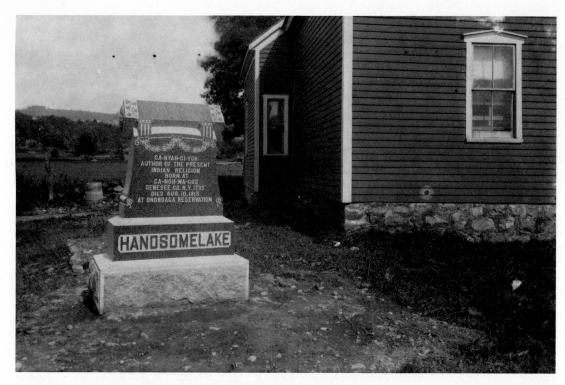

67. Handsome Lake's grave, just north of the Council House. A Seneca chief, Handsome Lake is regarded as the founder of the Longhouse religion, followed by Traditional Iroquois today. Beginning in 1799, a series of visions from the Creator moved him to preach a return to traditional values and more virtuous lives amid a time of great social instability. His message brought a spiritual renaissance to many Iroquois. c. 1905

68. The Condolence Ceremony of September 8, 1917. At this time, George H. Thomas was chosen to be Tohdadaho. Attendance was noticeably small, a concern during those in-between years, but the tradition endured. Standing, left to right, are Chiefs Charles Green and George Venevera. Three clan mothers are visible, opposite. *Courtesy of the Onondaga Historical Association*

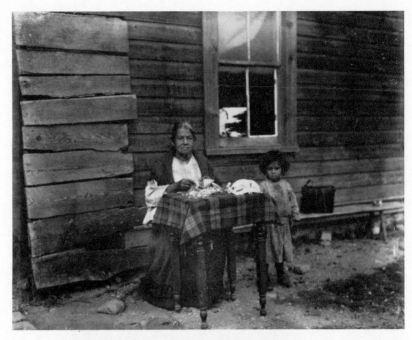

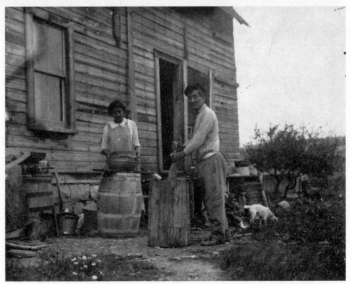

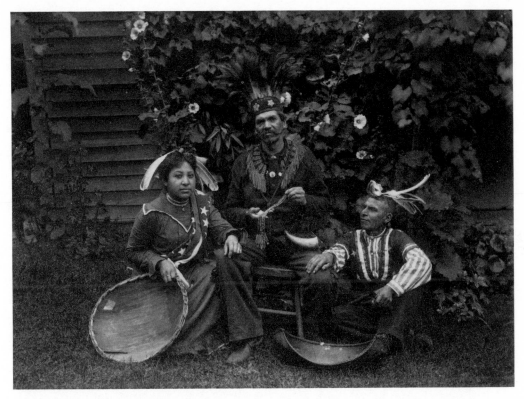

71. Melinda Johnson, Albert Cusick, and Philip Green in special-occasion dress. The bark basket and canoe model illustrate important Iroquois crafts. The headdress on either side is Iroquoian in form. Cusick is holding wampum strings, the traditional form of record keeping. c. 1910

69. (Left, top) Emma Isaac preparing beadwork. This traditional art form is, perhaps, the one most identified with the Iroquois although a tremendous variety thrives within the Confederacy today. c. 1905

70. (Left, bottom) Eli Scanandoah using a traditional wood mortar and pestle to pound corn into meal. Both the ancient native crop and the technique were common on the turn-of-the-century reservation. c. 1905

Index

Jones, Hiram, 37, 96
Jones, Joshua, 67
Jones, Mary, 35
Jones, Nelson, 93
Jones, Owen, 93
Jones, Phoebe, 67

Lacrosse, 3, 28, 38, 73, 84, 90–91, 99
Lafayette, N.Y., 26, 71
LaFort, Emma, 51
LaFort, Thomas, 36
Lake Mohonk Conference of Friends of the
 Indian, 6
Lincoln Institute, 6
Logan, Edd, 49
Logan, Eddie, 84, 97
Logan, Elsie, 91
Logan, Emma, 49
Logan, Frank, 56, 99
Logan, Lilly, 58
Logan, Mose, 58, 84, 89–90, 93, 96
Logan, Sidney, 85
Longhouse religion, 7–8, 20–21, 24, 61, 102
Lyons, Baptiste, 48, 95
Lyons, Clara, 48
Lyons, Emmett, 89–90
Lyons, Ike, 84, 89–90, 95–96
Lyons, Jesse, 30, 38, 84, 89–90, 96
Lyons, Julia, 38
Lyons, Rita, 48

Methodist Church, 8, 24, 60
Missionaries, activity among Onondagas, 6,
 8–9, 60
Morgan, Lewis Henry, 23

National Youth Adminstration, 29–30
Nedrow, N.Y., 17, 63
"New Deal" administration, 29
New York State, Iroquois and Onondaga
 relations with; as Dutch colony, 15, 17, as
 English colony, 15, 17; as state
 government, 7–10, 19–20, 25–27, 29–31,
 71
New York State Museum, 27, 86
Ninham, John, 44
Ninham, Molly, 44
Non-Intercourse Act of 1790, 19
Northwest Ordinance of 1787, 19
Northwest Territories, 19–20

Onondaga Castle Cornet Band, 57, 93
Onondaga Constitution of 1882, 24, 85
Onondaga County Dept. of Parks (Museum
 Office), 1–3
Onondaga Historical Association, 3

Parker, Arthur C., 27, 51
Parker, Eli, 21
Peace Maker, 13–14, 25
Pierce, Andrew, 72
Pierce, Jaris, 29, 50, 72, 85
Pierce, Lucy, 39
Pierce, Ulie, 84, 95
Plains, Western or Pan-Indian stereotype, 2,
 23, 75, 77, 79, 81–82, 85–87
Powless, Welcome, 95–96
Printup, Elmer, 89

Quaker Church, 8